Lucia Fornari Schianchi

CORREGGIO

SCALA/RIVERSIDE

CONTENTS

The illustrations for this volume come from the SCALA ARCHIVE, which specializes in large-format colour transparencies of visual arts from all over the world. Over 50,000 different subjects are accessible to users by means of computerized systems which facilitate the rapid completion of even the most complex iconographical research.

© Copyright 1994 by SCALA, Istituto Fotografico Editoriale, S.p.A., Antella (Florence)
Translation: Christopher Evans
Layout: Ilaria Casalino
Photographs: SCALA (M. Falsini, M. Sarri) except for: nos. 1, 77 (Vasari, Rome); nos. 6, 54, 74, 76 (Gemäldegalerie Alte Meister, Dresden); nos 7, 8 (Prado, Madrid); no. 10 (Museo del Castello Sforzesco, Milan/M. Saporetti); no. 16 (L. Pedicini, Naples); no. 18 (Izobrazitelnoye Iskusstvo); no. 52 (reproduced by courtesy of the Board of Directors of the Budapest Museum of Fine Arts); nos. 53, 73 (by courtesy of the National Gallery, London); nos. 78, 79 (Gemäldegalerie, Berlin); nos. 80, 81 (Kunsthistorisches Museum, Vienna)
Photocomposition: "m & m" Fotocomposizione, Florence
Colour separations: Mani Fotolito, Florence
Produced by SCALA
Printed in Italy by: Amilcare Pizzi S.p.A. - arti grafiche Cinisello Balsamo (Milan), 1994

1. Danaë, detail of the two cupids
Rome, Galleria Borghese

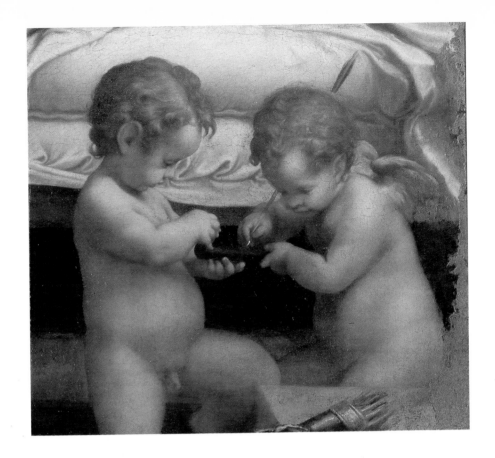

Biographical Notes and Early Works

It was in a city that still had a distinctly late medieval appearance and layout, and a population, according to the census of 1518, of 15,900, a city where economic and political stability were totally lacking, that two great artists of the Italian Renaissance developed and worked: Correggio and Parmigianino, complete opposites as far as their training, culture, and expressive aims were concerned. This city provided them with the opportunity to establish a fertile dialogue with their contemporaries and to carry out assignments of great significance, comparable to the works produced by Michelangelo and Raphael in Rome, by the early Mannerists in Florence or Siena, by Leonardo in Milan, and by Titian in Venice.

During the first four decades of the sixteenth century, the city of Parma was expanding and modifying its urban structure with the construction or enlargement of a number of major religious buildings. These were to become distinctive features of its urban and social fabric. Each of the city's religious communities set about renewing itself and, at closely spaced intervals, commenced extensive works of restoration: work was carried out on the church and monastery of Sant'Alessandro, on the church and nunnery of San Paolo, on the church and monastery of San Giovanni, on the church of San Quintino, and on

the oratory of the Immaculate Conception.

New creative energies were also released and set to work in the fields of sculpture, with major works of wood carving and terracotta molding, and of painting. Within a short space of time churches, oratories, and other sacred and profane places were enriched with canvases, panels, and meters and meters of mural decoration, leaving the profound mark of a mutable and multifarious culture. All this was the fruit of a great openness to what was going on elsewhere in Italy, both in the north and in the center, so that the walls of a chapel or the underside of a dome were decorated with specific and up-to-date styles and languages.

The archives, still not fully explored, contain extensive exchanges of correspondence, testifying to important changes in the centers of power and of cultural diffusion. There is rich evidence of connections, journeys, readings, requests, and orders that brought the city into contact with the themes of a variety of schools of paintings that were engaged in a continuous, and highly precocious, process of evolution.

In the fifteenth and sixteenth centuries, stylistic elements that had sometimes already been superseded in their places of origin were reproduced in Parma with excellent results. Influences came from Venice, mainly through Cristoforo Caselli and Filippo Mazzola who

based their altarpieces on the schemes used by the Vivarini family; from Padua and Lombardy with Bernardino and Jacopo Loschi; and from the culture of Umbria, Romagna, and Siena with Alessandro Araldi. Developments that had already reached their conclusion in Ferrara, Bologna, Cremona, and Mantua were reflected in the work of Francesco Tacconi, Benedetto Bembo, and Cesare Cesariano. In this setting, described to us by the historiographers with a great deal of uncertainty and many areas of obscurity, and of which few artistic testimonies have survived, the ground was being prepared for the second resplendent period of Parmesan art after that of the Middle Ages: the roughly twenty years, from 1519 to 1540, in which Correggio and Parmigianino were at work, leaving behind them a host of imitators and interpreters of their style, of their "manner," as has been emphasized on many occasions by a vast literature.

To take a new look at Correggio and his work, in this form, is an arduous task and one that is inevitably heavily indebted to all those authors, from Italy and outside, who, in past centuries and in recent years, have devoted themselves to patient and thorough research, deciphering documents, contents, and meanings or making delicate analyses of segments of his work or of his entire artistic output. In memorable pages, they have commented on his interpretation of the natural or the divine, his wonderful handling of perspective, his soft, skillful, delicate, and smooth brushwork, his use of chiaroscuro and back lighting, and his taste for artifice that overcame any geometric scheme, so that he even painted the air surrounding clouds and bodies. In short, they have unveiled those infinite categories of his painting, that have been so appropriately and succinctly defined in the English-speaking world as the Correggio system, and in the German one as *Correggieskes Ringschema*.

In order to reconstruct the course of the painter's career we have to rely not only on his surviving works, but also on the rare documents that bear his name, some of them concerning his private life and others his public affairs, as an established artist much in demand by a lay or religious clientele that competed in offering him important commissions.

Also useful are the written sources, biographical accounts, secondary sources, and past commentators, by means of which it is possible to attempt a reconstruction and investigation of his developing personality, as well as to focus on his training, his debut as a painter, and his maturation. Many obscure points still remain in his biography, however, commencing with his date of birth. Placed by many around 1493-94, it has recently been set back to 1489, on the basis of an indirect source, the deed of commission of the San Francesco Altarpiece dated 30 August 1514. Since the document bears neither the paternal consent nor

the endorsement by a judge that was required by anyone under the age of twenty-five making a written undertaking, it can be inferred that Antonio Allegri had already reached that age. He was born to Bernardina Piazzali degli Aromani (or Ormani) and Pelegrino de Alegris, a cloth merchant in Correggio, a small town in the Reggian countryside only 23 kilometers away from Modena, 17 from Reggio Emilia, 52 from Mantua, and about 40 from Parma. He married Gerolama Merlini who left him a widower after about ten years of married life and by whom he had four children.

In 1519 he moved to Parma, where he acquired a small property in 1530. Three years later he purchased a little plot of land in Correggio. He died at the age of forty-five, on 5 March 1534, having "received a payment of sixty crowns all in small coin, and wanting to transfer the money from Parma to Correggio to meet some of his expenses he started the journey on foot, carrying the coins on his back. Then as he was suffering from the heat of the sun he drank some water to refresh himself, and this brought on a raging fever which forced him to take to his bed; and he never raised his head again." The day after he was buried in the church of San Francesco in his native town, ruled in those years by the famous Da Correggio family, by Manfredo and the refined and learned Nicolò, who were succeeded by Borso and Giberto. The latter, following the death of Violante Pico, in 1509 remarried Veronica Gambara, a woman celebrated by Ariosto and Aretino for her intellectual gifts.

The critics are profoundly divided over his training and his earliest influences. It is said that his first teacher was Francesco Bianchi Ferrari from Modena, but there can be no doubt that the style that left the greatest mark on his early works was the one developed in Mantua by Andrea Mantegna and Lorenzo Costa.

Indeed it has been suggested that Correggio might have been responsible for the Evangelists Matthew and Luke depicted in the pendentives of the vault of Mantegna's mortuary chapel in the church of Sant'Andrea (1506). Another, and far from secondary, influence unquestionably came from the works of Francia and above all of Raphael. The latter had sent some particularly innovative paintings to Emilia, including the *Sistine Madonna* (for the church of San Sisto in Piacenza, now in Dresden, the *Saint Cecilia* (now in the Pinacoteca in Bologna), and the *Ezekiel* (formerly in Casa Hercolani in Bologna, now in Florence).

Although these tendencies continued to have an influence on his work, they were gradually superseded by a new interest in the paintings of Leonardo, and in the solutions adopted by Raphael and Michelangelo in Rome. Correggio may have visited that city some time prior to 1519, and this is now unanimously accepted by the critics.

Any attempt to reconstruct the course of his de-

*2. Madonna and Child with Angels playing
Musical Instruments
20x16,3 cm
Florence, Uffizi*

velopment as a young man is still beset by many difficulties; his biography appears to be dotted with conditionals, with hypothetical contacts with the works of Giorgione, Pordenone, and Lorenzo Lotto.

Vasari himself, frequently an indispensable source, is vague and summary in his account, even though he devotes attention to the painter, acknowledging the particularly original characteristics of his work.

In the "Preface" to the third part of the *Lives*, for instance, Vasari emphasizes that he belonged to "the third style or period, which we like to call the modern age [consisting in] force and robustness of [...] draughtmanship, [...] subtle and exact reproduction of every detail in nature, [...] an understanding of rule, a better knowledge of order, correct proportion, perfect design, and an inspired grace," which was originated by Leonardo and continued by Giorgione and Fra Bartolommeo, who gave to their works "strength, relief, charm, and grace," and to an even greater extent by Raphael, "whose colors were finer than those found in nature." "Raphael's style influenced Andrea del Sarto," and one cannot ignore "the charming vivacity of the paintings executed by Antonio da Correggio: this artist painted hair, in an altogether new way, for whereas in the works of previous artists it was depicted in a labored, hard, and dry manner, in his it appears soft and downy, with each golden strand finely distinguished and colored, so that the result is more beautiful than in real life."

In the *Life of Allegri*, inserted after those of Leonardo and Giorgione and followed by those of Piero di Cosimo and Bramante, Vasari dwells on the personality of the "outstanding painter," stating that he "was a very mild man and all his life, for the sake of his family, he was a slave to his work, which brought him great distress." This suggests an intense activity aimed at earning the money that would permit his family to live a less wretched life, as well as possible investments in the purchase of land. It is not surprising that, on the basis of these comments, Wittkower (*Born under Saturn*, Turin 1968) places Correggio among the parsimonious painters: "The miserly are usually portrayed as insecure people, anxious about an uncertain future since they lack faith in their own talent." Now it is not impossible that the young artist, still in search of a measure of self-confidence, may have experienced painting as an exhausting trial at the beginning, until his creative genius began to come into full flower at around the age of thirty. In fact Allegri was a painter whose capacity for expression only reached its height after a difficult and uncertain period that lasted longer than was due and that still presents complications and contradictions for critical interpretation.

So before we come to the year 1519, which marks the watershed between his juvenile and late-juvenile activity, hinging entirely on the style of archeological classicism developed by Mantegna and the Paduan school, or on the solutions proposed in Ferrara by the young Garofalo and Dosso and the soft and dense manner of Giorgione, it is necessary to examine around twenty of his earlier works. These are among the most significant of the initial part of his career, many of them paintings of small format that do not break with tradition. They show that he was still anchored in the pictorial culture that had developed, in various forms, in the area stretching from Mantua to Ferrara, and from Bologna to Modena.

The earliest expression of this period appears to date from 1507, when the painter was about eighteen. The mortuary chapel of Mantegna in Sant'Andrea is surmounted by a small, circular cupola decorated with a double plaitwork of canes that support a counter-structure of vegetation pruned to form small arches. This stands on the framework of the four sprandels in which are portrayed the Evangelists, paintings that critics have identified as the first, stylized and restrained, work of Allegri.

To the years 1508-10 belong a group of works with no reliable dates and distinguishing marks. The first of these is the *Saint Catherine with the Palm*, now in the National Gallery in London and originally from the Layard bequest, where it had been attributed to Garofalo. The painting differs quite markedly from Correggio's customary style of those years, revealing a competence and decisiveness that suggest a considerably later date.

On the other hand, the *Madonna and Child with Saint Elizabeth and the Young Saint John* from the Johnson Collection in Philadelphia and the small panel depicting the *Madonna and Child with Angels playing Musical Instruments* in the Uffizi in Florence can be more reliably placed among his early works, owing to their close resemblance to other paintings from this period. In the latter, the chiaroscuro is softened by the back light set "against a gold ground," framed by a mass of clouds out of which emerge two angels plucking the strings of their instruments. The head of the Virgin is bowed, and her intense expression is shaded by the folds of the thick mantle that covers a delicate and transparent veil, knotted over her breast. Her hands delicately brush the Child, in a gesture and attitude that are echoed by those of the angel on the left, as if the latter were intended as a replica. Up until the end of the last century, this work too bore another name, that of Titian, to whom it was attributed owing to its Venetian luminosity, a feature that was also characteristic of the early Correggio. In the *Marriage of Saint Catherine*, from the Kress Collection (Washington), the small and stocky figures and the stylized drapery hark back to the paintings of Mantegna and to the style of Francia and Costa, although there are also subtle references to Lorenzo

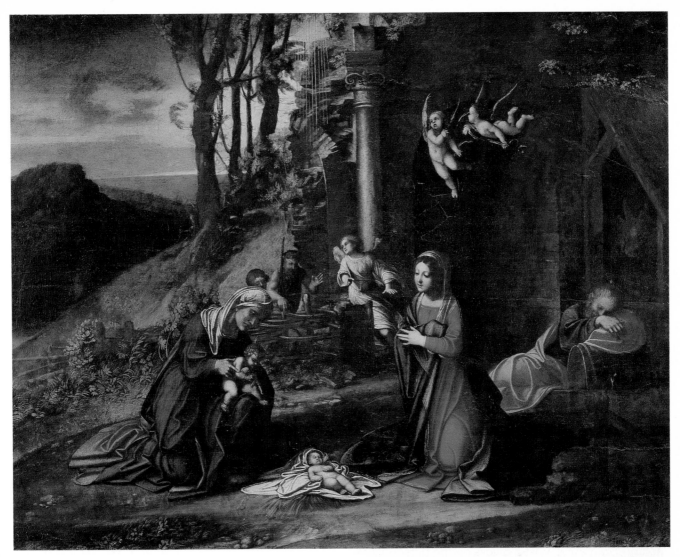

*3, 4. Madonna and Child with Saint Elizabeth
and the Young Saint John
77x99 cm
Milan, Pinacoteca di Brera*

Lotto in the crystalline atmosphere and the gentle in-
tensity of emotion, an element that seems to repeated-
ly link the two artists. The execution of the small panel
from the Crespi Collection in the Pinacoteca di Brera
of Milan should be dated to around 1512-13. This
depicts the *Nativity*, with the sleeping figure of St
Joseph contrasted by the watchful adoration of the
Virgin and the rapt pose of St Elizabeth. The dimly lit,
almost nocturnal setting both brightens and softens the
colors, accentuates the lines of the drapery, empha-
sizes the shrubs that are painted in the manner of Dos-
so and Leonardo, and gilds the column that is used to
subdivide the scene in a perfect relationship between
solid and void, between building and nature.

Recent and exhaustive studies have proposed Cor-
reggio's intervention in the refectory of the monastery
of San Benedetto Po, around 1511-14, at the request
of Gregorio Cortese. In this view the artist was respon-

sible for a monumental scene of classical architecture based on a perspective view of a row of Corinthian columns, interspersed with figures and angels. These seem to derive from Raphael's majestic works in the Vatican, in particular the *School of Athens* and the *Expulsion of Heliodorus*, completed around the middle of 1512.

The theme is an intriguing and fascinating one and, once again, presents us with the difficult problem of reconstructing the course of development and the stylistic definition of Correggio's language.

The elements of this work that seem to fit most closely with Correggio's style of those years are the monochromes depicting the *Sacrifice of Isaac and Melchizedek* and representing bas-reliefs on the bases of the row of columns.

The same cannot be said of the two tondi, datable to around 1514, portraying the *Holy Family* and the *Deposition*. These are frescoes detached from the porch of the church of Sant'Andrea in Mantua that, owing to their now fragmentary, almost totally compromised state of preservation, do not permit any relevant comparison, even though the still legible design, the *sinopia* traced in black with a brush, does reveal a connection, even on the technical plane, with the sinopia detached from the dome of Parma cathedral during the recent restoration and now in the Galleria Nazionale of that city. The confusion of lines is also reminiscent of the technique used in certain of Correggio's folios, such as the study *Madonna with Saint Jerome* in Oxford. The grimace of pain, almost a shriek, that can be seen in the tall figure to the right of the deposed Christ, and that is more clearly visible in the preparatory cartoon in the Pierpont Morgan Library in New York, traces back a line of experience that seems to connect the artist with Ercole de' Roberti and with certain expressions of profound suffering to be found on the faces of the Virgin and of the two Marys in the 'Lamentations' of Niccolò dell'Arca and Guido Mazzoni in Bologna, Modena, and Busseto. These were undoubtedly esteemed by Correggio for the sensitive portrayal of faces and expressions typical of Emilian artists working with terracotta from the sixth and seventh decade of the fifteenth century onward.

Correggio imbues the Virgin with the same impression of sorrow in the *Christ taking Leave of his Mother* in the National Gallery in London, dated variously to 1513-14 or 1516-18.

Here the space is subdivided in the same way as the *Nativity* in the Pinacoteca di Brera, this time by an Ionic column that separates, with perfect symmetry, the scene of the swooning from the light blue and violet landscape, as well as from the horizon which is greatly dilated to the point where it converges on the white robes of Christ.

The altarpiece now in Dresden, depicting the *Ma-*

donna and Child with Saints Anthony of Padua, Francis, Catherine of Alexandria and John the Baptist (Madonna with Saint Francis) and dated to 1514-15, has a more complex structure.

It could be described as Correggio's first true picture. It is still influenced by Mantegna in the "enthroned" representation of the Virgin, which echoes the protective gesture of the *Madonna della Vittoria*, by Leonardesque chiaroscuro in the chromatic register of the John the Baptist, and by Raphaelesque mysticism in the ecstasy of the saints. But it already shows the first signs of a cultural crisis that was now approaching its height and its resolution. The layout of the work is based on a succession of polished Ionic columns that are used to define the space opening onto the landscape and to contain the elegant and overloaded throne supported by telamones in the form of putti.

The latter lean against a tondo, almost a cameo, portraying Moses. The flight of angels and putti, not without a hint of Costa, is still far away from the tangle

5. Andrea Mantegna
Madonna della Vittoria
Paris, Louvre

6. Madonna with Saint Francis
299x245 cm
Dresden, Gemäldegalerie

9

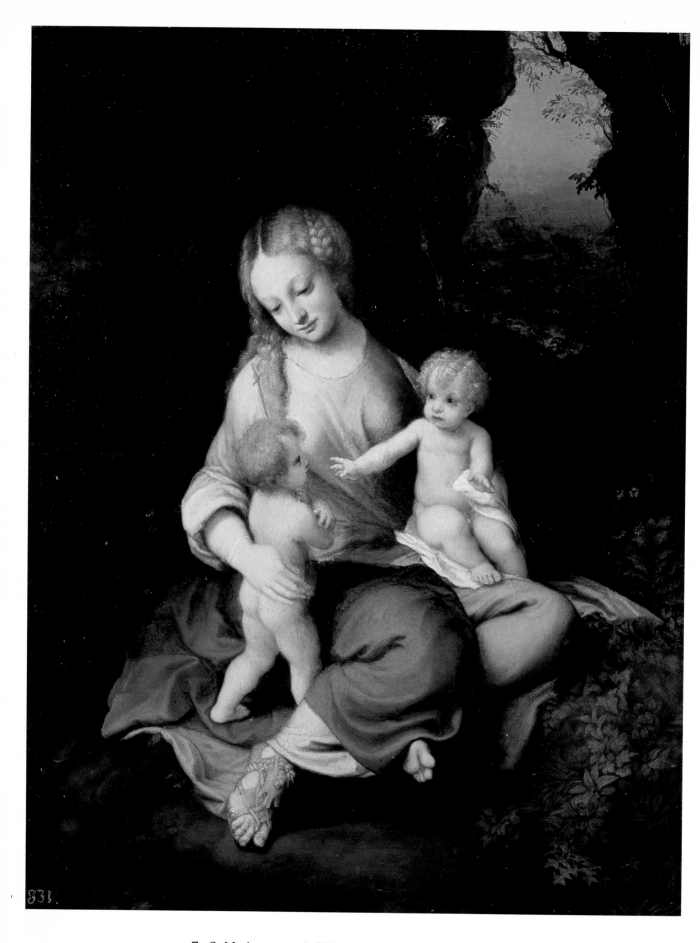

7, 8 Madonna and Child with the Young Saint John
48x37 cm
Madrid, Prado

10

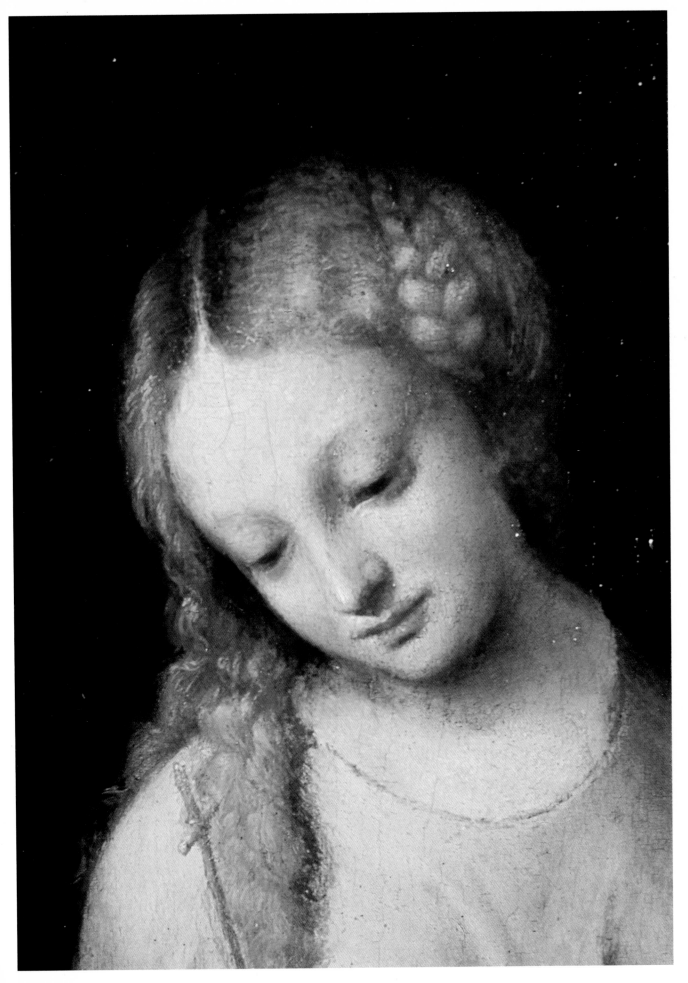

9. *Madonna Zingarella (Gypsy Woman)*
49x37 cm
Naples, Museo di Capodimonte

10. *Madonna and Child with the Young Saint John*
68x49 cm
Milan, Museo del Castello Sforzesco

of members that were to appear in his domes or paintings in the third decade of the sixteenth century. In this picture, however, a new and more modern, more engrossing language began to unfold, the first sign of a development that was to lead to many original discourses. These did not emerge with immediate continuity, but slowly, in fits and starts, moving toward the consolidated tradition and the modernity that Correggio was beginning to glimpse and to make his own.

In fact in the *Holy Family*, in the County Museum of Los Angeles, datable to around 1516, Correggio seems to return to customary and already tested schemes, probably at the request of his clientele, who had learned to appreciate a certain reassuring charm, a particular setting. Thus we have here a stock theme that was successful and easy to repeat.

In 1516 he was commissioned to paint the tiny, but extremely interesting, *Madonna and Child with the Young Saint John*, now in the Prado in Madrid but originally from the collection of Elisabetta Farnese. This painting contains a typically Leonardesque feature, perhaps as filtered through the work of Luini.

The pose of the Virgin with her hair plaited into soft braids, the classical footwear that peeps out from beneath the cunning folds of her clothing, and above all the landscape with that opening — almost a ravine out of which shines a profound, mysterious light, with a detailed description of the small clusters of flowers and leaves in the foreground — are reminiscent of the *Virgin of the Rocks* and the *Leda and the Swan*, of Leonardo at his most enigmatic and original.

The *Four Saints* in the Metropolitan Museum of New York, assigned a date of around 1517, also has a number of elements in the manner of Leonardo, especially in the Mary Magdalen with the onyx jar and the Saint Martha indicating the winged monster. Here Correggio resorts to an axiality of composition that is reminiscent of Raphael's *Saint Cecilia*, now in Bologna, and uses a wonderful range of bright and telling colors, in perfect contrast with the impenetrable stretch of woodland, barely pierced by the light.

A marble pilaster strip, with a hardly perceptible decoration, delimits a wide opening onto an extraordinary luminous landscape, in front of which are seated the *Madonna and Child with the Young Saint John*. This painting, formerly in the Raccolta Bolognini and now in the Museo del Castello Sforzesco in Milan, is dated to 1514-17. Motifs and attitudes are drawn from the school of Leonardo and in particular from the *Madonna dei Fusi*, but there are also references to and correspondences with the Venetian paintings of Bellini and Cima in the way the picture is framed and in the element of archeological reinterpretation.

Another interpretation of intimist tone is to be found in the *Madonna and Child with the Young Saint John*, believed to date from around 1517 and now in the Art Institute of Chicago: yet another version of a subject that had almost become a trademark of the artist, in which he introduces a favorite effect behind the Virgin, that of the fence of reeds holding back a hedge of fruits and leaves, again in the manner of Mantegna, while the soft and hazy passages of the landscape bring us back to the Ferrara area.

With the *Madonna Zingarella (Gypsy Woman)* in the Museo di Capodimonte in Naples, dubitatively assigned to 1517, Correggio introduces a new scheme of composition, almost a reworking in the modern key of the Gothic theme of the "Madonna in the Garden."

His figure, however, is not rigidly posed, in royal robes, on a pillow of flowers, but bends tenderly over the child in a protective gesture of Manneristic effect. It is in reality a "rest on the flight into Egypt," even though St Joseph is missing. Graphic emphases and detailed descriptions are mixed in the landscape, creating a unitary and hazy effect, something that is also, and unfortunately, accentuated by the fragmentary condition of the picture that even the recent restoration has not succeeded in making completely decipherable.

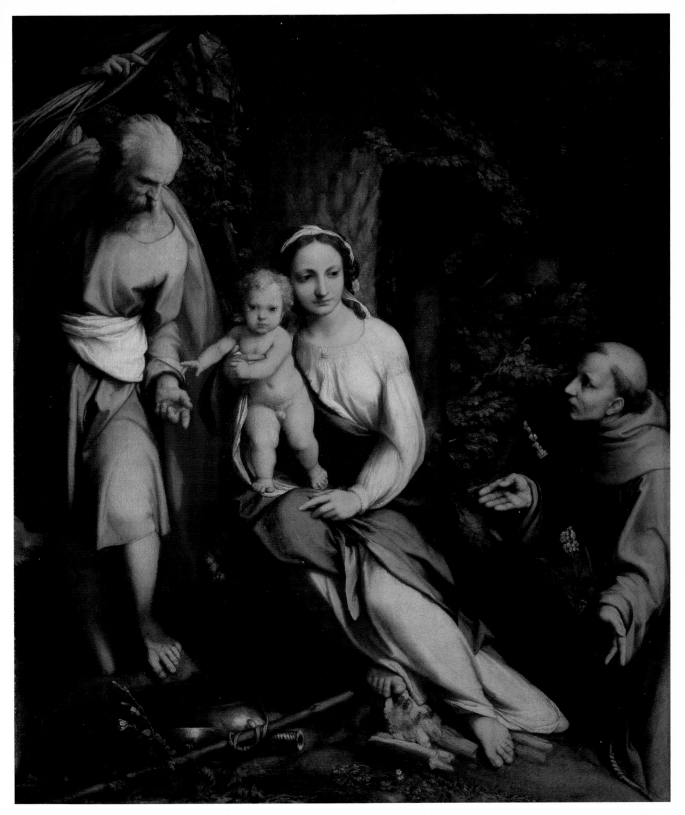

*11, 12. Rest on the Flight into Egypt with
Saint Francis
123,5x106,5 cm
Florence, Uffizi Gallery*

The other *Rest on the Flight into Egypt with Saint
Francis*, in the Uffizi, appears to date from the same
year. Larger in size, it was painted by the artist for the
Munari chapel in San Francesco at Correggio. The

painting reveals that he has achieved a different level
of maturity in his treatment of stylistic features drawn
from Leonardo, which are combined with personal in-
tuitions derived from the early Tuscan Mannerists,
from Andrea del Sarto to Beccafumi, elements that
are already to be seen in other, earlier paintings. Note
the slanting pose of the Virgin, who is leaning against
the trunk of a palm tree, the vigorous gesture of St
Joseph as he offers the Child dates, and the piece of

still life with the flask and pewter dish placed in the foreground.

Notwithstanding the differences of opinion, the *Campori Madonna* in the Galleria Estense of Modena can be dated to 1517-18. Here one finds a medley of references to Leonardo and Raphael that are clearest in the bowed head of the Virgin and the gesture of the Child who catches hold of his mother's hand and shoulder as if to lift himself up.

The palette, too, has been lightened, shifting toward discreetly rosaceous and subtly changing tones. With this work, we are coming closer to the watershed, and it is possible to glimpse the developments of the future. The artist inflates the bodies and veils, uses more modernly rounded forms, and goes beyond the crystalline detail and snapshot-like motionlessness of his earlier work, which will gradually be transformed into naturalness, convexity, soft and blurred lustre, canceling of outlines, and confidence and independence of invention. These characteristics become even more visible in the *Adoration of the Magi* in the Pinacoteca di Brera, dating from around 1516-18. A myriad of figures move through the painting, in a conventional set of attitudes, as if the Magi and their retinue were dancing a gentle ballet. A yellowish ivy plant climbs over the parapets and a swarm of angels rendered ashen by the shifting light of a cloud link up with the severe landscape in the background: it is a blend of elements from Mantegna and Costa, reexamined in the light of the early Tuscan and Emilian Mannerism of Garofalo, Aspertini, Leonbruno, and Beccafumi, to which are added references to Venetian painting, especially that of Giorgione and Lotto. With this painting the distance becomes even more apparent, although some experts insist on the temporal proximity of the two works with the *Nativity*, also in Brera, and whose date has been set back to 1512-13, which seems to refer to a very remote past from both the cultural and the stylistic point of view, echoing the stylistic features of Mantegna and the early Garofalo.

The *Mystic Marriage of Saint Catherine*, now in the Museo di Capodimonte in Naples and formerly in the Farnese Collection in Parma, is dated to the years 1518-20 and provides further confirmation of the influence of Beccafumi's Mannerism in that period. It is an influence that Correggio seems to have felt on more than one occasion, even though, unlike the almost contemporary Parmigianino, he would never embrace it completely. Instead, he would keep his options open, even moving in the direction, shortly afterward, of decidedly classicistic forms. This work is characterized by a compact and lumpy texture, by a carefully balanced symmetry between the two figures, and by the now customary device of the open background with shifting light and forms, a feature that makes him one of the greatest interpreters of nature in

the Cinquecento. In this sense there is an inevitable link with the *Noli me tangere* in the Prado, which is dated by the critics to sometime between 1518 and 1524. The latter is an intense and refined work, which presents similarities to Titian in the figure of Mary Magdalen and a Leonardesque attitude of particular rigor in the pose of Christ, who is represented, having stripped off his gardener's clothing, in front of a luxuriant landscape. The coloring of this landscape is particularly effective, partly as a result of the back lighting of the great trunk that acts as a theatrical wing, pushing back the expanse of woodland. The elimination of certain graphic emphases of Mantuan derivation gradually led Correggio to adopt a more fluid use of color along the lines of Venetian and Ferrarese painting, helping us to understand that shift, that evolution in his style, that was to make him *primus inter pares* within the space of a few years.

Between 1517 and 1519 he also painted the important *Portrait of a Gentlewoman* in the Hermitage in St Petersburg, a work that has aroused a great deal of debate and that critics had been reluctant to place in Correggio's catalogue until a few years ago, owing to its previous attribution to Lorenzo Lotto. No one has yet identified the illustrious lady that it portrays, but the picture bears comparison with Raphael's *Woman with a Veil* and Leonardo's *Mona Lisa*, and can justifiably be seen as an anticipation of Parmigianino's *Turkish Slave Girl*. The three-quarters-length portrait is set diagonally in such a way as to emphasize not only the elegant headgear of braided ribbons gathered by a precious clasp, but also the ample *décolletage* and the gauzy sleeves from which the hands barely emerge. In them she holds an elaborate cup of nepenthe with a Greek majuscule inscription, on its inner border, taken from Homer's *Odyssey*.

Beneath this cup can just be seen a piece of the cord of a member of the Franciscan tertiary. These last elements have led critics to suggest that the subject is Veronica Gambara, mistress of the town of Correggio, portrayed at the age of thirty-two, probably immediately after the death of her husband, Conte Gilberto da Correggio, on 26 August 1518. On that date the artist must have been in Rome, but he could have painted the picture immediately after his return. The throne is covered with the same yellowish ivy that had appeared in the *Adoration of the Magi* in the Brera.

Against it rest bright green branches of laurel that enclose the figure in the foreground and create a wonderful contrast with a scene of open countryside that is caressed by a sky of lapis lazuli.

This portrait seems a fitting precedent to another commission from a woman, the one he received in 1519 for the decoration of the vault of the dining room in Giovanna da Piacenza's private apartment in the Benedictine nunnery of San Paolo in Parma.

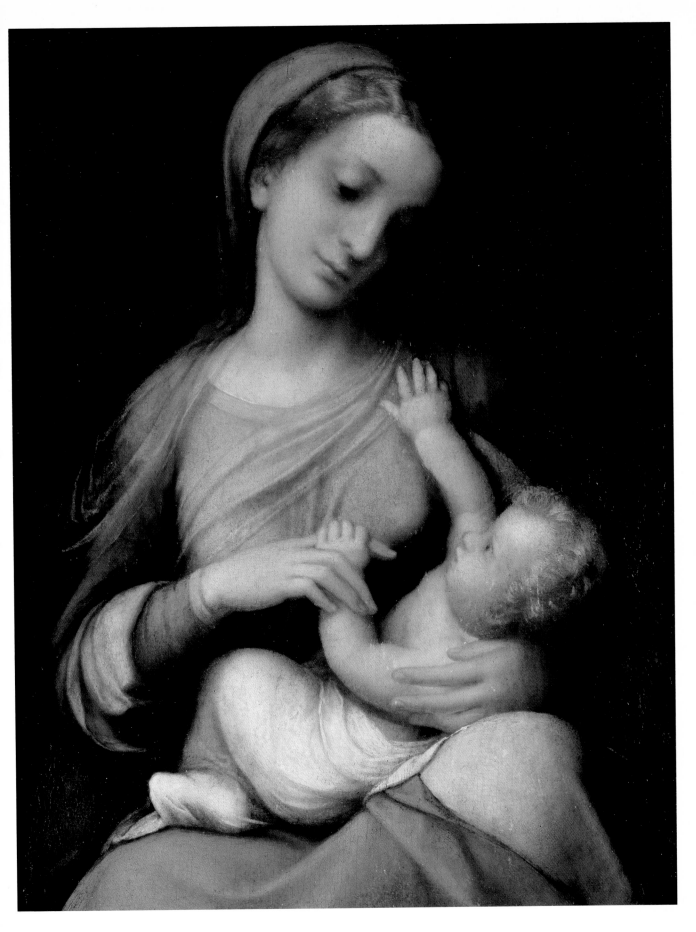

13. Campori Madonna
58x45 cm
Modena, Galleria Estense (formerly)

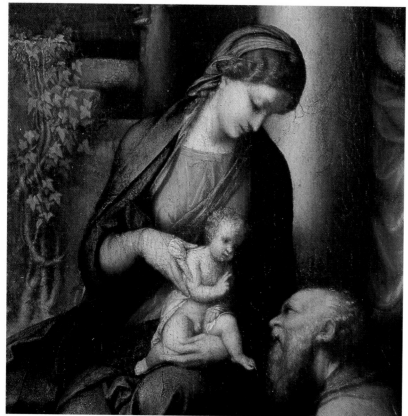

14, 15. *Adoration of the Magi*
84x108 cm
Milan, Pinacoteca di Brera

16. *Mystic Marriage of Saint Catherine*
28x24 cm
Naples, Museo di Capodimonte

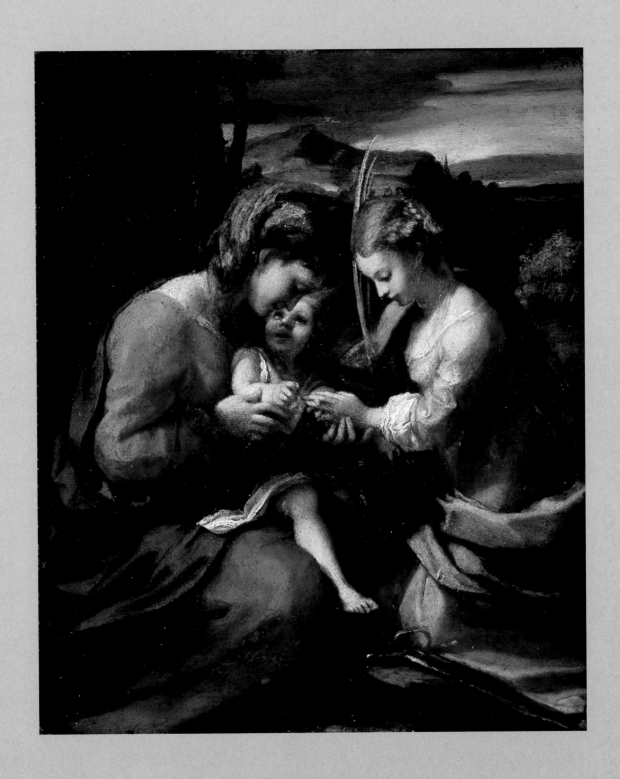

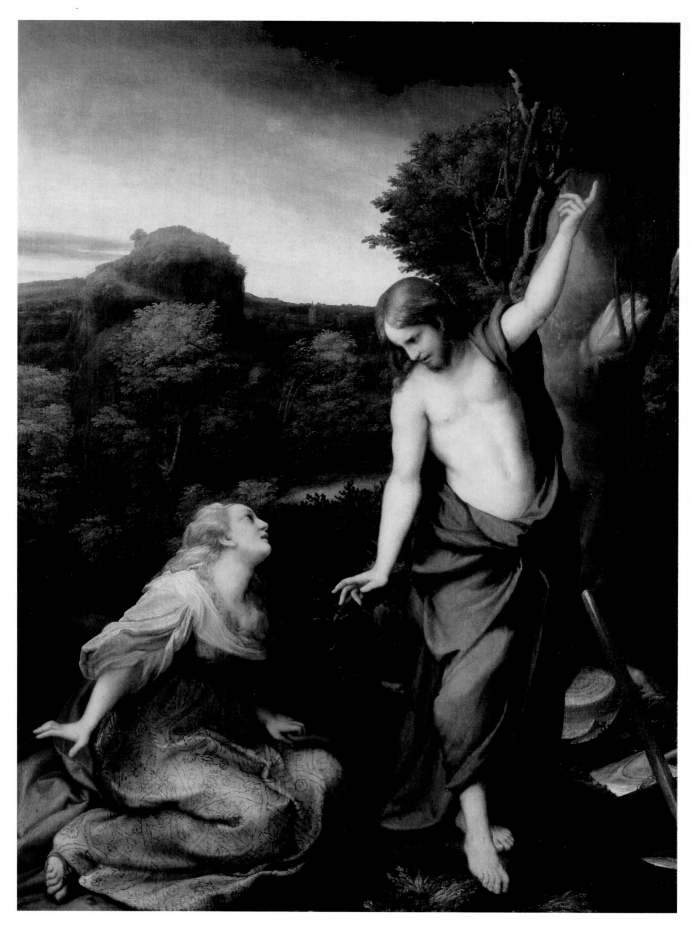

17. Noli me tangere
130x103 cm
Madrid, Prado

20

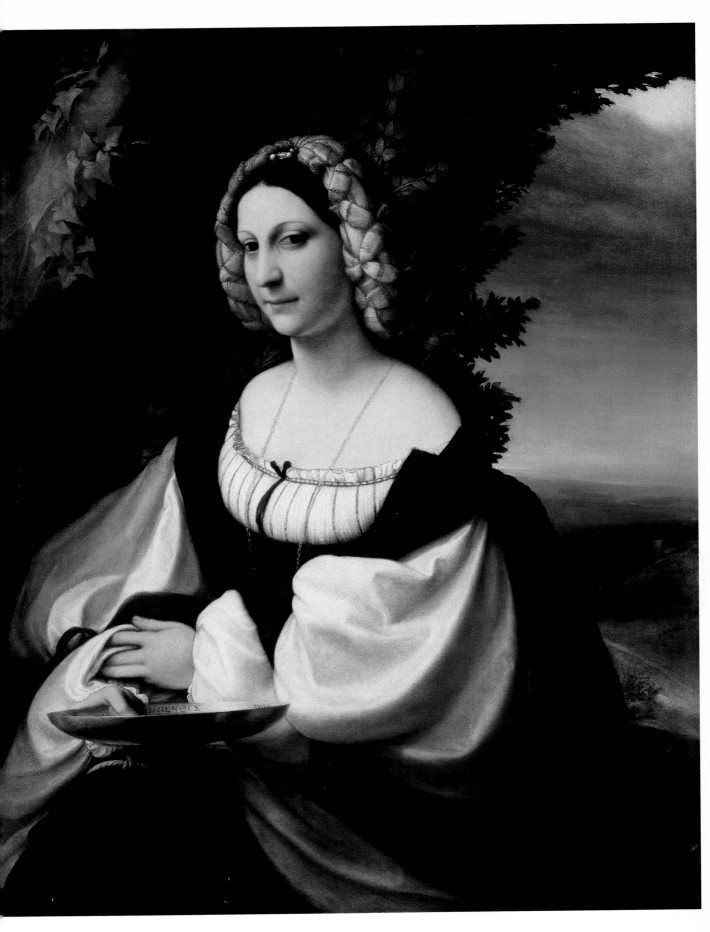

18. Portrait of a Gentlewoman
103x87,5 cm
St Petersburg, Hermitage

The Chamber of the Nunnery of San Paolo

This work truly marks the turning of a new leaf in Correggio's activity: here we see the birth of a new painter who, from this moment on, can compete on equal terms with Leonardo, Raphael, and Titian. It is the beginning of the "natural style," the category in which Mengs places the works of those artists who had no "other aim than to have been able to copy nature, as chance presented it to them, or as it ordinarily appears."

Vasari makes no mention of the work, and no reliable documents relating to it have been uncovered so far. It remained unknown until 1794, when it was discovered for the first time as a result of two visits. One of them came about fortuitously through the interest of a certain Ghidini, "highly esteemed merchant of Parma," who was accompanied by "four worthy men" and artists into the bargain; Gaetano Callani, Francesco Rosaspina, Biagio Martini, and Francesco Vieira. They entered the room on the morning of 6 June and stayed there until six in the evening, "astonished and speechless... almost ecstatic." The other visit took place a few months later, on 2 October, this time by the Duke of Parma Don Ferdinando of Bourbon, Bishop Adeodato Turchi, "three chamberlains," and "four men of culture": Martini, Callani, and Ghidini again, together with Father Ireneo Affò. The latter was to dedicate to the "chamber" his invaluable 'Discussion of a room painted by the very famous Antonio Allegri da Correggio'. This detailed description finally revealed the existence of the room that had remained mysteriously unknown to most people for such a long time, owing to the enclosure of "that venerable cloister," to which only a few people were permitted entry. One of these had been the Benedictine monk from the Abbey of Montecassino, Father Maurizio Zappata, who in 1709 had written some notes in Latin about the churches of Parma, mentioning that in the nunnery of San Paolo *ornatur Coenobium picturis Corrigii* and reaffirming, in another manuscript in the Biblioteca Palatina, that the nunnery contained *fabulosae imagines a magno Corrigio adumbratae*.

And so this masterpiece of the Italian Renaissance was gradually unveiled to the eyes and to the pen of the critics, who devoted as much attention to it on the stylistic plane as on the iconographic one. Yet, in spite of these painstaking interpretations, the paintings are still cloaked in profound and enigmatic mystery.

Between the end of the fifteenth and the beginning of the sixteenth century the nunnery of San Paolo became, as well as the center of the community of Benedictine nuns, one of the most active meeting places for intellectuals in the city. This activity was dominated by the family of Giovanna da Piacenza herself, the Bergonzi. A few decades earlier the whole block, including the gardens, had been surrounded by walls, and later on painters, carvers, inlayers, and ceramists were called to counter the influence of other religious centers, such as the monasteries of San Quintino, dominated by the Sanvitale family, and of Sant'Uldarico, in the hands of the Carissimi family. The nunnery of San Paolo was headed from 1507 to 1524 by Giovanna da Piacenza, an astute, cultured, and youthful mother superior (she was only twenty-eight). It was she who entrusted Alessandro Araldi, in 1514, with the decorations of the refectory and the first chamber, and Correggio, in 1519, with those of her private dining room. The artist's taste was in full accord with the culture and attitude of a great lady of the Renaissance, who was able to rely on such excellent advisers as the Protonotary Apostolic Bartolomeo Montini, the vicar-general of the diocese Lattanzio Lalatta, and the illustrious humanists Francesco Maria Gropaldo, Jacopo Caviceo, Taddeo Ugoleto, and, above all, Giorgio Anselmi. The latter was a scholar of Greek, Latin, philosophy, and classical antiquities and the probable inspiration behind this chamber.

In fact the relations between the Benedictine nuns and the Da Correggio family dated back many years, to the time when Araldi had used the beautiful Beatrice da Correggio, the wife of Nicolò Sanvitale who was mentioned by Ariosto and celebrated by Enea Irpino, as the model for the face of St Catherine, painted in the cell of the same name. The painting can still be seen, on the north side of the garden of San Paolo.

Correggio undertook the commission after a probable journey to Rome around the end of 1518. This visit is now generally accepted as having taken place, notwithstanding the absence of any records.

The artist made skillful use of the ribs of the umbrella vault, built according to late Gothic schemes by Giorgio Edoari da Erba, camouflaging them with a trellis that supports a huge *berceau* of fruits and flowers: a larger and more stately version of those areas of greenery that, ever since the mortuary chapel of Mantegna in Sant'Andrea, had never completely vanished from his paintings, whether they were portraits or sacred scenes. The decoration starts at the top, as if uncoiling out of the skillfully represented tangle of pink ribbons that surrounds the gilded medallion with three crescent moons, the symbol and coat of arms of his patroness. These panoplies of fruit gathered between boughs of oak leaves are reminiscent of the famous decorations used for Renaissance festivals, recorded in a certain type of secular painting that shows us the taste of people at that time for natural compositions, for festoons, and for works of garden architecture, in

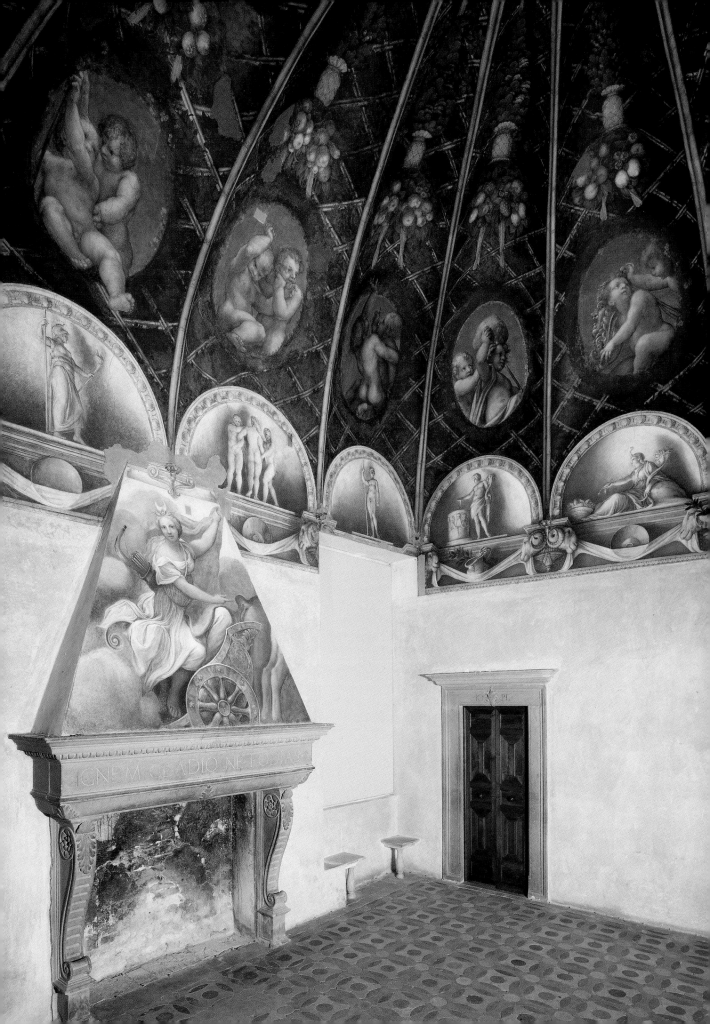

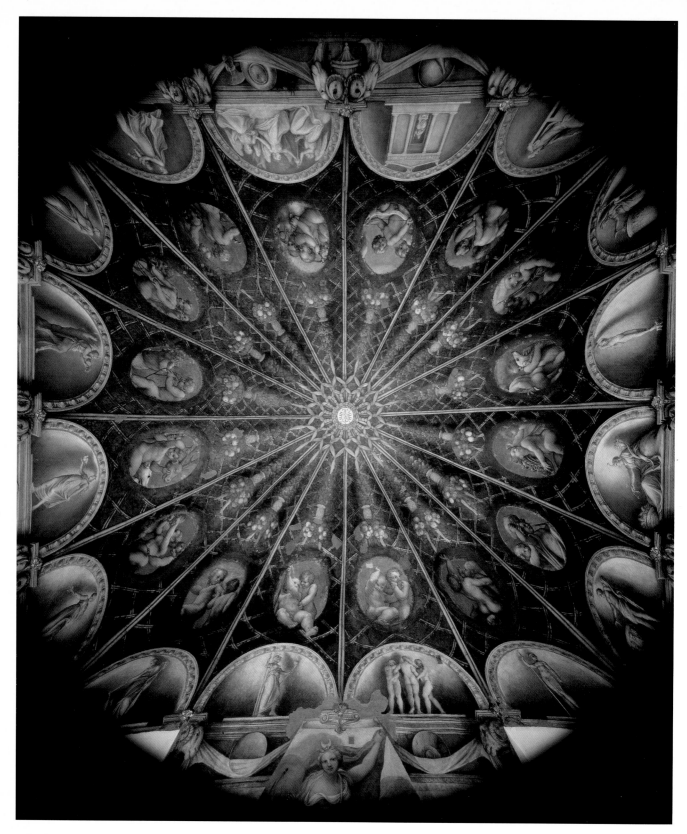

which each creeper was guided to form a harmonious pattern. These would then be pruned to open up arches and to embellish the hedges with mutable forms. Here Correggio makes oval openings in the interlacing vegetation, through which enter the day, the light, and the sky, and out of which appear lively putti bearing the symbols of the hunt: arrows, a horn, dogs, a bow, and a stag's head. Below these he inserts four

19, 20. View of the Camera di San Paolo and of the vault
Parma

21. Detail of an oval with a putto embracing a dog
Parma, Camera di San Paolo

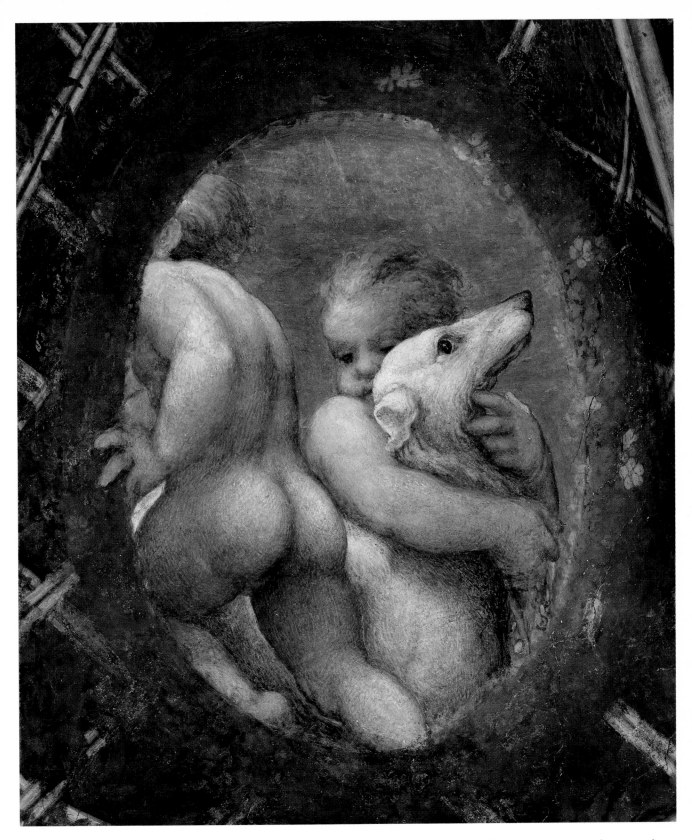

lunettes on each side, framed by soft shells that contrast with the marble structure of the figures, taken from classical coins and medals. The *trompe-l'œil* achieves a particular virtuosity. The concave niches, illuminated in such a way as to match the natural source of light from the windows, contain the most significant figures of classical mythology, represented as statues of onyx, ivory, and Greek marble. At their feet, after a small projecting cornice, Correggio again changes key, returning to the "natural": a tangible expression of the culture of the Po Valley from which he had taken the ideas that he found most congenial, even though there is no lack of references to Rome, of citations from Raphael and from antiquity, which had got into his blood through his contacts with Mantegna and with the archeological collections of the Gonzaga family.

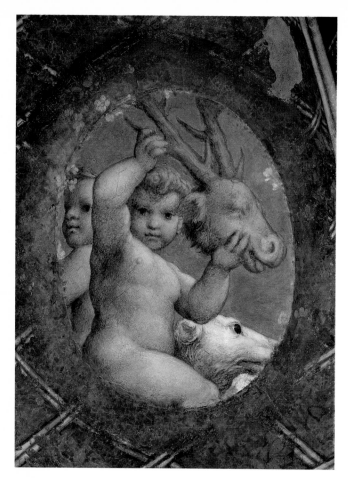

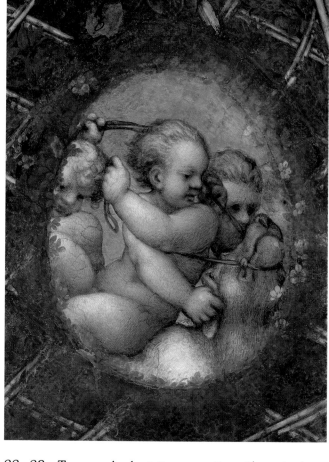

22, 23. Two ovals depicting a putto with a stag's head and a putto with a greyhound Parma, Camera di San Paolo

And so he adds living, though decapitated, rams' heads: not *bucrania*, therefore, as in ancient sarcophagi, but animals that are still warm in their rosy, subtly ocherous hues. And he alternates and links them together with a long white cloth, part shroud, part bandage, that is pulled downward by the weight of pitchers, plates, and gold, pewter, and silver bottles: these too are symbols of the feast, of the gathering after the hunt. On the hood of the fireplace, of traditional trapezoidal shape, he places Diana, dressed in ample folds of clothing and wrapped in clouds. Standing on a chariot drawn by two hinds, she is setting off for the hunt, as if in rapture. The inscription on the fireplace, *Ignem gladio ne fodias* ("Do not stir fire with sword"), seems to be taken from the verses of Callimachus and to be a self-dedication, in that Giovanna for years refused enclosure for her nunnery, opposing the will of Popes Julius II and Leo X. Only Clement VII succeeded in imposing cloistered life on the community, which came into force a mere twenty days before the death of the mother superior.

It is likely that the walls were covered with tapestries with plant decorations. The character of the decoration is at once imaginative and consistent with a commemoration of classical culture. There have been many different interpretations of the chamber: each scholar has seen in it a set of enigmatic and perhaps never completely decipherable messages, so that it appears completely impossible to give even a summary of them here, except to mention briefly the possibility that the painted elements were intended as a combination of *speculum naturale* (the four elements) on the east side of the vault, *speculum morale* (the virtues) on the west and north side, and *speculum doctrinale* (the divinities) on the south side. Thus one would enter the room, passing through the four elements (air, water, earth, and fire), to find oneself facing the virtues that regulate human conduct and induced to meditate on the will of Fate, which determines everything that happens and which not even the gods can escape. The arbor, in addition, has been interpreted as an expression of contemplative virginity.

There can be no doubt that this room, after five centuries, still contains a mysterious force of communication that is proper to all works of art, but in particular to those that are an expression of a refined and enigmatic culture, almost a culture of initiation.

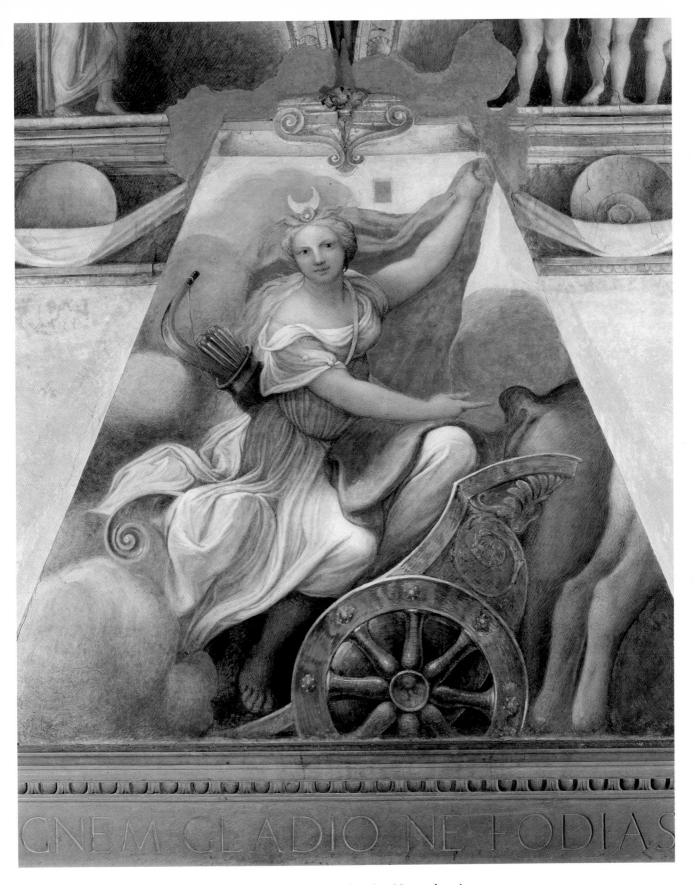

*24. Diana departing for the Hunt, fireplace
Parma, Camera di San Paolo*

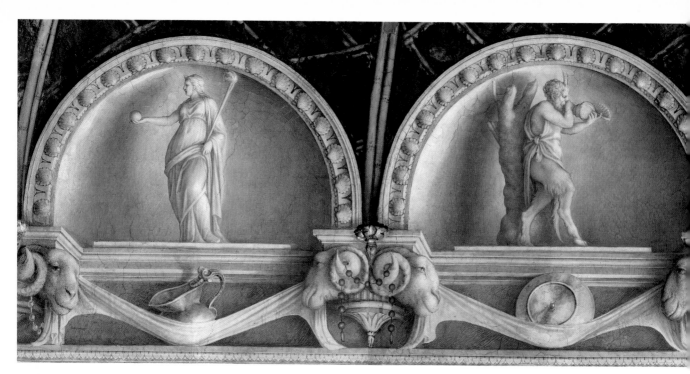

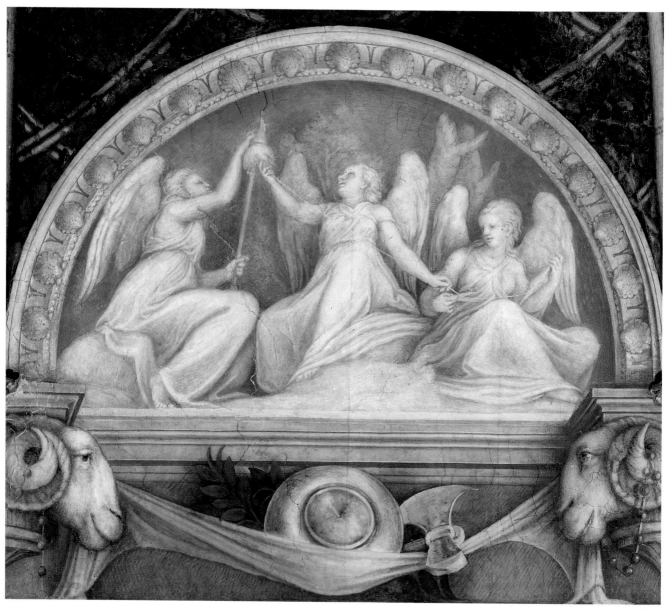

28

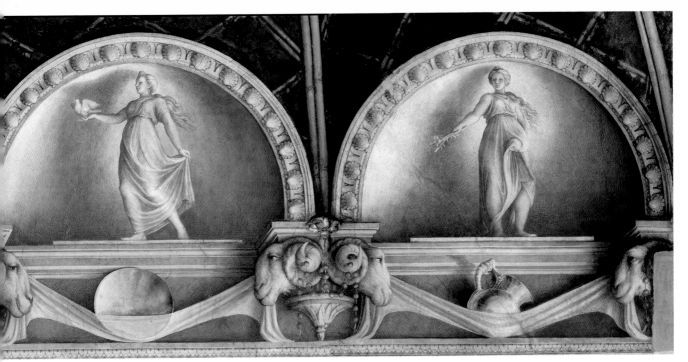

25. Lunette of the west wall depicting
Light-bringing Diana, Pan, a maiden
with a dove and another with a lily
Parma, Camera di San Paolo

26. Lunette of the south wall with
the Three Fates
Parma, Camera di San Paolo

27. Detail of the lunette with the
Three Graces
Parma, Camera di San Paolo

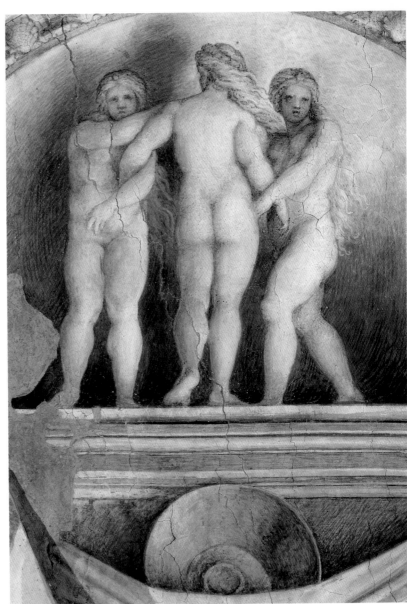

29

The Works for the Monastery of San Giovanni Evangelista

The marked change in the language adopted by Correggio, occurring over the space of a few years, and the break that this involved with his earlier style of painting, is made even more apparent by a careful analysis of the decorations that he realized, between 1520 and 1524, in another great Benedictine construction in Parma, the church of San Giovanni Evangelista.

It is in fact a confrontation between the factors that brought about and revealed a crisis in Parmesan painting and a subsequent rebirth, an updating of figurative languages introduced and brought to maturity by Correggio on the one hand and Parmigianino on the other. It suffices to compare the chamber decorated by Araldi and his other works in San Pietro and in the cell of Santa Caterina, along with his paintings in Parma's Galleria Nazionale, the altarpieces of the Mazzola family and Cristoforo Caselli, and the frieze, dated 1514, in the transept of San Giovanni, to understand the leap, the sudden change introduced by Correggio with the overall glow and sense of illusion that is to be found in his mature domes and paintings. There were a variety of reasons for this change. One was his early contact with Tuscan and Roman culture, and his interest in the influences that were coming from Tuscany and Umbria by way of Bologna, where the painting of Perugino was filtered through the works of Francia and Costa.

We also know that, after 1506, the year of the pontifical conquest of Bologna and the consequent expansion of the Papal States to include Modena, Parma, and Piacenza, a number of examples of high Roman culture were introduced into the Po Valley: from the grand staircase in the manner of Bramante in the Palazzo Pubblico of Bologna, which bears the coats of arms of Julius II, to the renowned altarpieces by Raphael in Bologna depicting *Saint Cecilia* and the *Vision of Ezekiel*, formerly in Casa Hercolani and now in the Palazzo Pitti in Florence) and Piacenza (*Sistine Madonna*). Then there was the great bronze statue cast by Michelangelo for the facade of San Petronio, visible for only three years after it was set in place before being destroyed in 1511, as well as the works by a still little-known assistant of Michelangelo, a certain Bernardino Zacchetti, in the churches of San Prospero in Reggio Emilia and San Sisto in Piacenza. Some Ro-

28, 29. Passing away of Saint John or Vision of Saint John on the Island of Patmos, cupola Parma, Church of San Giovanni Evangelista

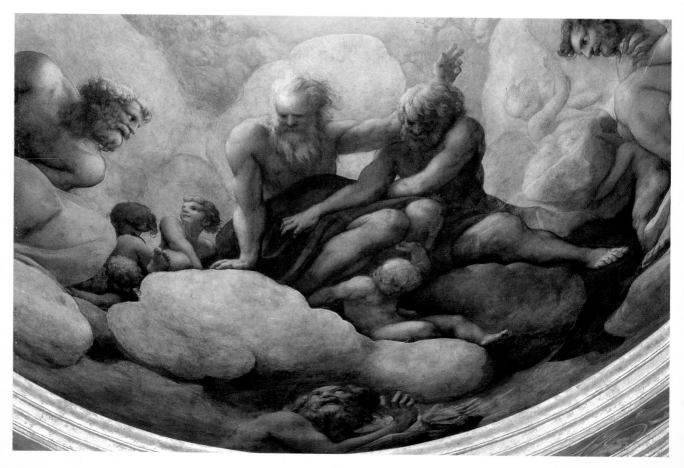

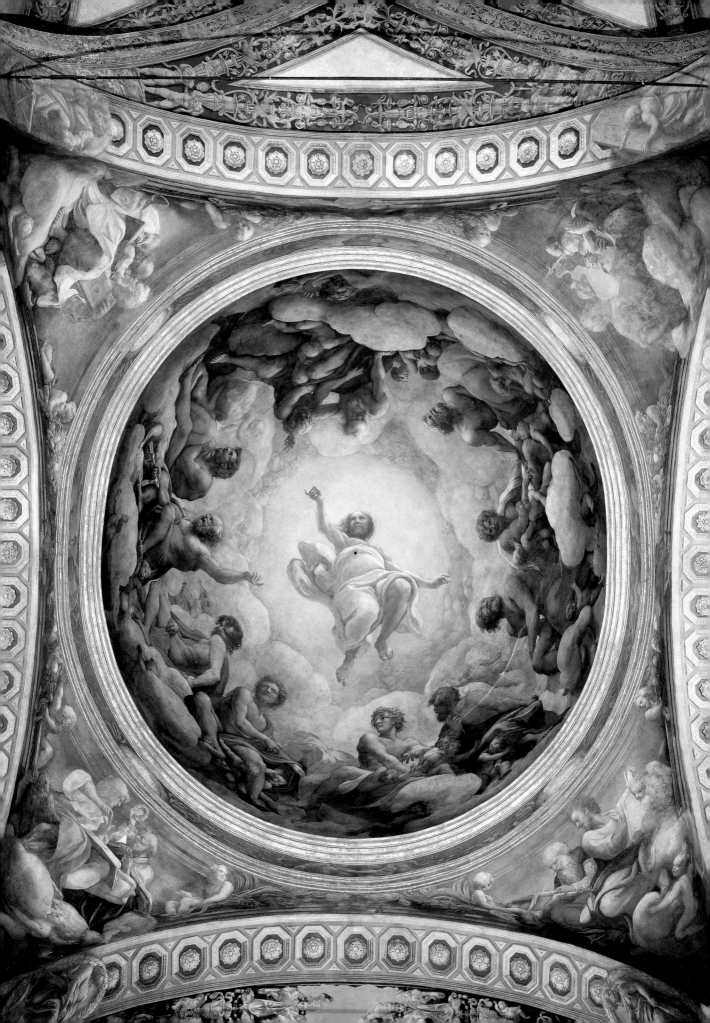

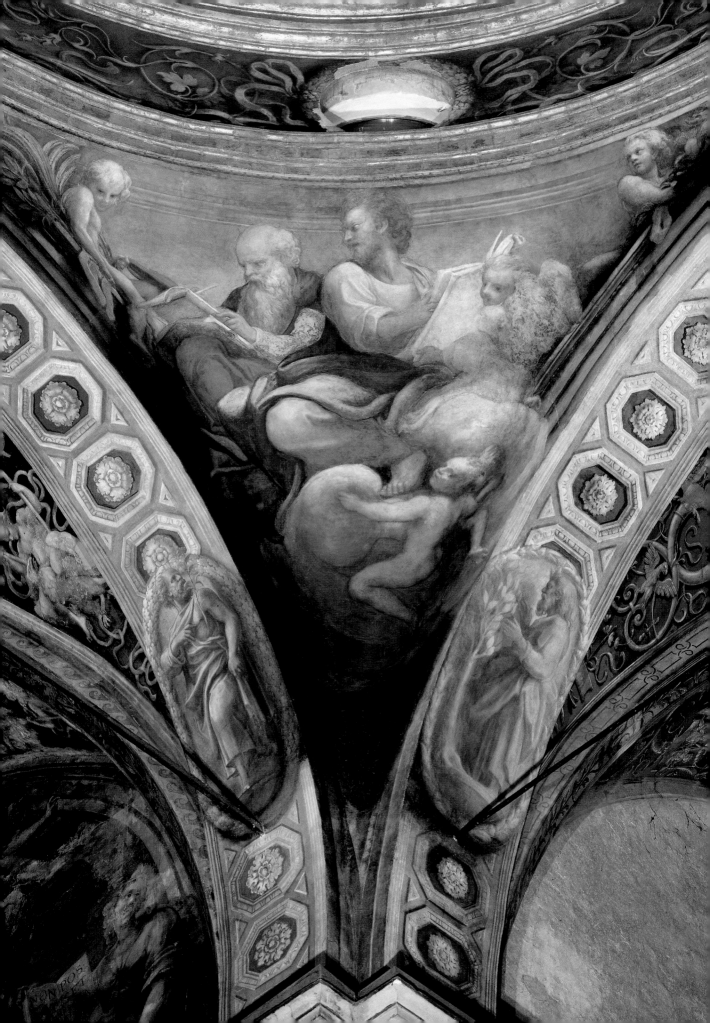

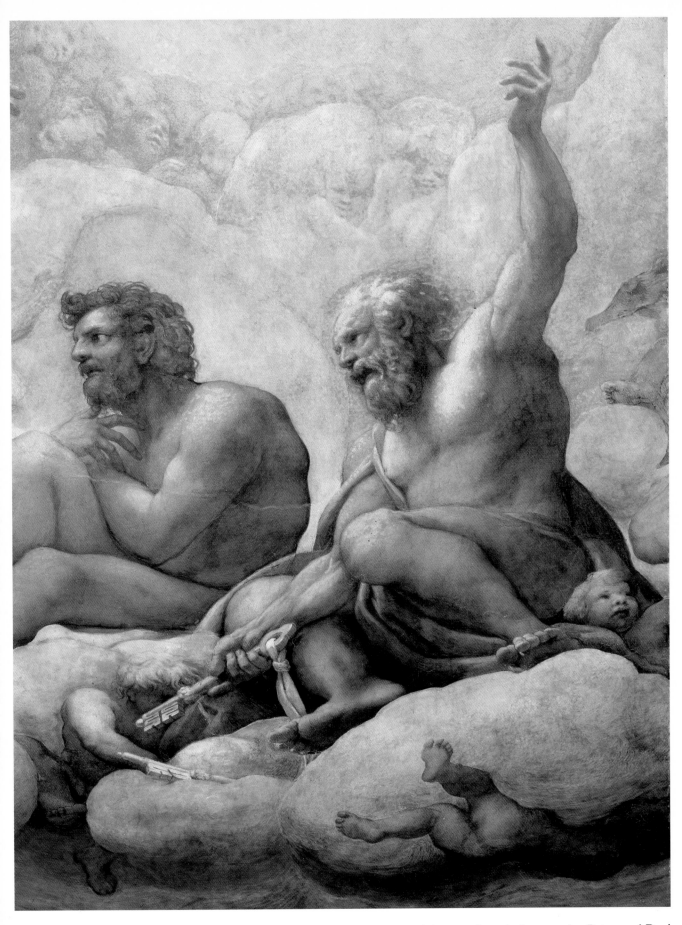

30. *Pendentive with Saint Jerome and Saint Matthew*
Parma, Church of San Giovanni Evangelista

31. *Detail of the cupola with the apostles Peter and Paul*
Parma, Church of San Giovanni Evangelista

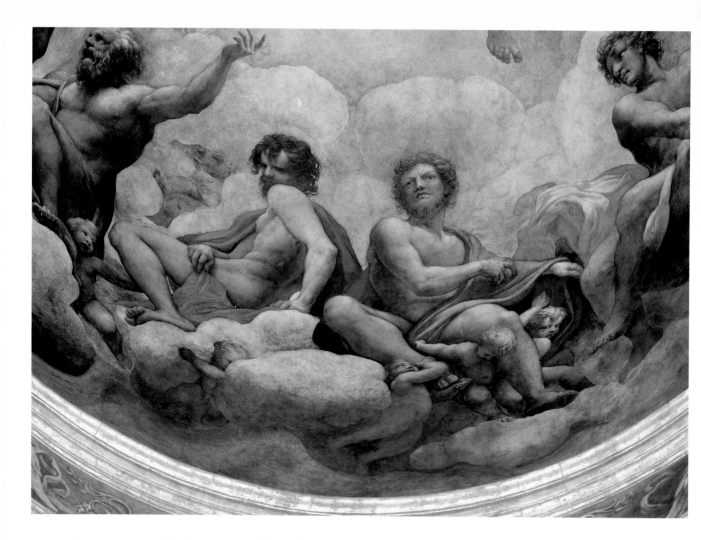

man influences must also have come through Pordenone, along with Titian's mode of expression, especially in his works for Cremona, where Boccaccio Boccaccino and Gian Francesco Bembo had developed a similar style. Above all, however, this change in language is thought to derive from a visit to Rome in 1518, or perhaps from two visits, one of them much earlier, in 1513. Yet there is no documentation of either and they remain suppositions, part of that area of obscurity out of which emerged the second, and grandiloquent, period of Correggio's career.

There is no doubt that a visit to see Michelangelo's decoration of the ceiling of the Sistine Chapel, already fairly well advanced by 1512, and to Raphael's Stanze in the Vatican, commenced in 1508 and completed in 1511, and in particular an examination of the *Disputa*, the *School of Athens*, and the *Expulsion of Heliodorus*, as well as of the wall decorated with the *Triumph of Galatea* in the Farnesina or the *Prophet Isaiah* in Sant'Agostino, could not have left Correggio indifferent. Yet, in his early works in Parma, it was the language rather than the nature of his painting that changed, thereby enriching with new expressive capacities the texture, the layout, the light, and the space of his pictorial technique. We are still impressed today by the rapidity with which Correggio adopted

32-34. Details of the cupola with the apostles Philip and Thaddeus, James the Less and Thomas, Andrew and James the Great
Parma, Church of San Giovanni Evangelista

the new style and by its unexpected maturity. This made its first definitive appearance in San Giovanni, an undertaking for which the contracts and records of payment only allow us to draw incomplete conclusions.

It is known that the painter was commissioned to decorate the dome with its pendentives, the apse of the main chapel, the candelabrum motifs in the transept over the high altar, and the frieze of the nave. Uncertainties over interpretation have split the critics, some of whom see the work as having commenced with the vault of the apse and others with the dome. There is more support for the latter hypothesis, in part because it makes it possible to suppose, for the first time, a direct contact between Allegri and the young Parmigianino, on that very scaffolding. It is in the dome, in fact, that Correggio was able to make use of his ample forms, brimming with naturalness, and of his fragmentary handling of light, that gradually dissolves and is transformed into back lighting, emphasiz-

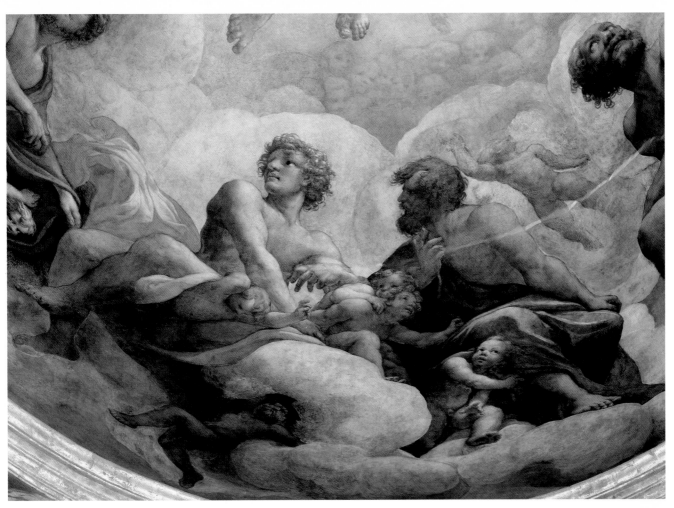

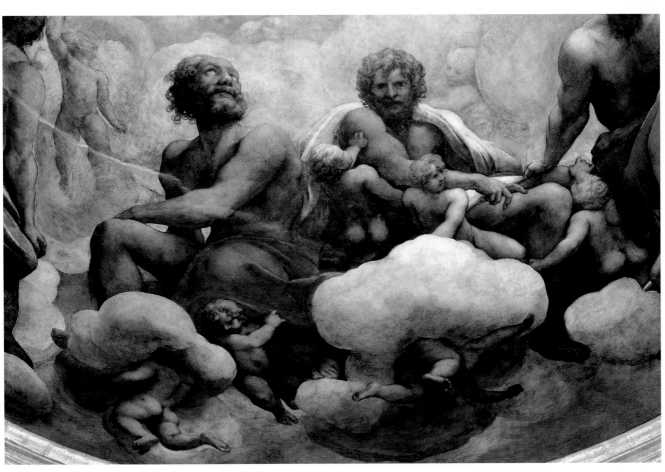

ing the solemn and massive frames of the Apostles. However, having defined the restricted set of figurative correspondences adopted by Correggio, and recalled the very few preparatory drawings that have survived, it remains to look at the influence of the theme entrusted to the artist by the Benedictines and to examine the way in which he handled it, with an iconographic connection that links together all the most important parts executed over that period of four years.

The dome, whose vault has no lantern and only receives light from the four *oculi* set in the drum, was reserved for the illustration of the *Passing away of Saint John*, the last of the Apostles to die, aged over a hundred, at Ephesus.

It is a traditional belief that at the moment of his death Christ came to meet him, surrounded by all the Apostles. Earlier interpretations of the scene had been

that it represented the *Vision of Saint John on the Island of Patmos* or even the *Ascension*.

In the pendentives are depicted, in pairs, the four evangelists (Matthew and the angel, Luke and the bull, Mark and the lion, and John and the eagle) and the four Fathers of the Church (Jerome, Ambrose, Gregory, and Augustine). The decoration extends onto the undersides of the arches, connected by an ornamentation of lacunars in which are inserted eight episodes drawn from the Old Testament: *Cain killing Abel*, *The Sacrifice of Abraham*, *Samson tearing down the Gates of Gaza*, *Jonah emerging from the Whale's Mouth*, *Moses in front of the Burning Bush*, *Aaron with the Flowering Rod*, *Elijah on the Chariot of Fire* and *Enoch Borne up into Heaven*.

It was, without question, an unprecedented decoration for a dome. Correggio interprets the *Descent from the Cross* at the center of the vault in masterly fashion,

35. Parmigianino
Detail of the putto
between the
pendentives of the
north side
Parma, Church of
San Giovanni
Evangelista

36. Detail of the putto
to the side of the
pendentive with
Jerome and Matthew
Parma, Church of
San Giovanni
Evangelista

37, 38. Frieze
depicting the
Christian Sacrifice
Parma, Church of San
Giovanni Evangelista,
chapter house

surrounding the image by a rarefied golden light that has the effect of directing the gaze beyond the tangible, beyond the barrier formed by the architecture. The absence of geometrical divisions, of breaks, simultaneously pushes the eye toward the center and the periphery, toward the focal point, or rather the focal points coinciding with the divine image and with the still terrestrial one of St John that is set above the molding, and only visible from the area of the apse. This creates a circular void of color that is split up between the clouds, the Apostles, and the upper circumference, rarefied to the point where it becomes a cone of light. This unnatural light of Neoplatonic inspiration flows up to, breaks against, and pierces the grayish clouds on which the Apostles are seated at their banquet, with their naked torsos and their immobile poses. They are barely draped by strips of bright yellow, red, blue, and green cloth, introduced more to meet the need for color than for any real necessity of historical connotation.

37

39. *Coronation of the Virgin*
215,5x330 cm
Parma, Galleria Nazionale (formerly in the apse of
San Giovanni Evangelista)

40. *'Sinopia' of the Coronation of the Virgin*
Parma, Biblioteca Palatina

*41. Lunette with Saint John the Evangelist
Parma, Church of San Giovanni Evangelista above
the entrance to the cloisters*

Once the Benedictine monks had decided on the themes, it was up to the artist to arrange them, interpret them, and raise them to the level of the sublime, rendering them effectively vibrant and vital through the use of his highly original codes of interpretation on his own initiative. For the same church, Correggio executed the *Coronation of the Virgin with Saints John the Evangelist, Benedict, Maurus, and John the Baptist and with Angels playing Music and singing.* This contrasts strongly with the bower pruned to form a series of superimposed arches, through which penetrates the golden light that brightens the clouds of this section of Paradise. This effect can now only be deduced from the copy made *in situ* by Cesare Aretusi, in 1586, after the original fresco had been partly saved and reconstructed in a larger and more elongated area of the apse. Today, unfortunately, only a few sections of the fresco have survived, and are now to be found in the Galleria Nazionale and the Biblioteca Palatina in Parma, where the *sinopia* is set in the wall at the end of a long corridor.

Despite the limited size of these fragments, it is possible to understand the influence that the work had on the Carracci, who made several copies of it, in that the illusory effect used by the artist, the synthetic but impressive pose, was well-suited to the dictates of Counter-Reformation painting laid down by Bishop Gabriele Paleotti in Bologna.

Correggio accentuates, here, the use of that dense, intensely golden light of his, which almost seems to originate from the Byzantine conches of the apse and that ignites the stars of the crown. The latter is set on the Virgin's head by Christ, in a sublime gesture that is absolutely new to contemporary Italian art. The light has a profound symbolic function, as well as serving as a device for involving the observer emotionally and esthetically. It also permits the artist to abandon the geometric division of the espalier of greenery, derived from Mantegna and Raphael, in order to create a totally free area, punctuated solely by the figures that are set in total isolation or crowded together, forming an almost energetic heavenly court. Correggio's work in San Giovanni continues with the "grotesque" decoration of the ribs of the transept above the high altar. The decorative elements rise from the angels with an eagle, the symbol of St John, to turn into marble patterns on a blue ground, as soft as the chiaroscuros in San Paolo. He also painted the two scenes of *Christian Sacrifice*, now in the chapter house of the monastery, and the lunette over the door leading into the cloisters. Here, once again, he portrays *Saint John* as the young evangelist with his eagle, in the act of writing the gospel. The artist also supplied some designs for the band painted by F. Maria Rondani on the walls of the nave and for the panels of the external arch of the Del Bono chapel.

His "Gentle" Madonnas and "Intense" Martyrs

At the same time as this vast and demanding commission was being carried out Allegri executed a number of other works and received requests for more.

The *Madonna della Scala*, a fresco detached from the facade of the oratory of the Blessed Virgin Mary (formerly at Porta San Michele) in 1812 and now in the Galleria Nazionale of Parma, was painted around 1523. The image of the Child tenderly clasping the Virgin is described by Vasari as follows: "Over the gates of the same city Correggio also painted a Madonna and Child; and it is astonishing to see the lovely coloring of this fresco which has won him the most enthusiastic praise, even from passing strangers, who have seen nothing else of his."

With this work, which has survived in a very fragmentary state, Correggio continues and renews his stereotype of the female and maternal figure. He aims for a gentle grace that can be seen in the Virgin's face, with its lowered eyelids and hint of a smile in the manner of Leonardo, in contrast to the liveliness of the Child, enfolded in the reassuring arms of his mother and in the full and gauzy drapes. The colors of the latter contrast with the soft texture of the rosy landscape set between the two columns.

The reference to Raphael and his tender madonnas has grown still more obvious, to the point of suggesting not just a stylistic but even an emotional tie, especially with the *Madonna di Foligno* and the *Madonna della Torre*.

The *Annunciation* set in a lunette, a detached fresco that is now in the Galleria Nazionale of Parma, was commissioned from Correggio by the Observant Friars Minor, who had a church and monastery "outside Porta Nuova," in the southern part of the city and near the area now occupied by the Cittadella. The commission was probably received around the beginning of the twenties, though there is now a tendency to date the execution of the work to between 1524 and 1526. The scene represents the sudden appearance of the heavenly messenger, in his billowing white robes, bearing the news of the happy event to the Virgin in prayer. The figure of the latter is twisted to convey her immediate response to the appeal and, at the same time, her total submission to the divine will. This lends movement to the scene, cunningly set under a portico opening onto natural surroundings. It provides yet another example of the maximum of attention that Correggio always paid to the presentation of the theme, the attitude of his figures, and the choice of their setting.

Between 1524 and 1525 Correggio painted the two horizontal canvases for the Del Bono chapel in San Giovanni, depicting the *Deposition* and the *Martyrdom of Four Saints*, now in the Galleria Nazionale in Parma. The measurements of the two pictures painted as companion pieces, and the unusual shape of the figures, which never fit completely into the scene, are probably due to the original dimensions of the chapel, which was subsequently enlarged. The artist was almost compelled to adopt certain solutions, as he had to squeeze six figures for each painting into the space available to him. The result, almost by necessity, was in many ways a completely new interpretation. In the *Deposition* the figures are

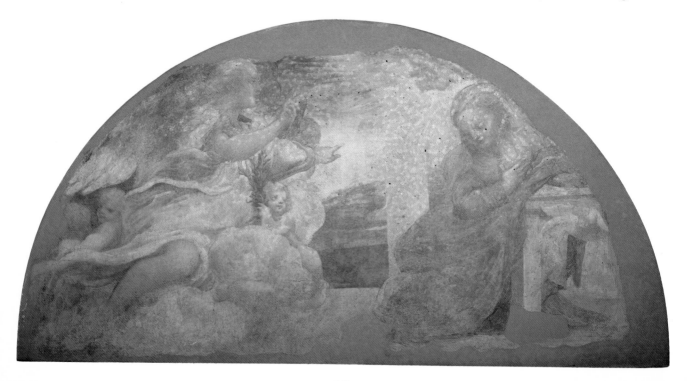

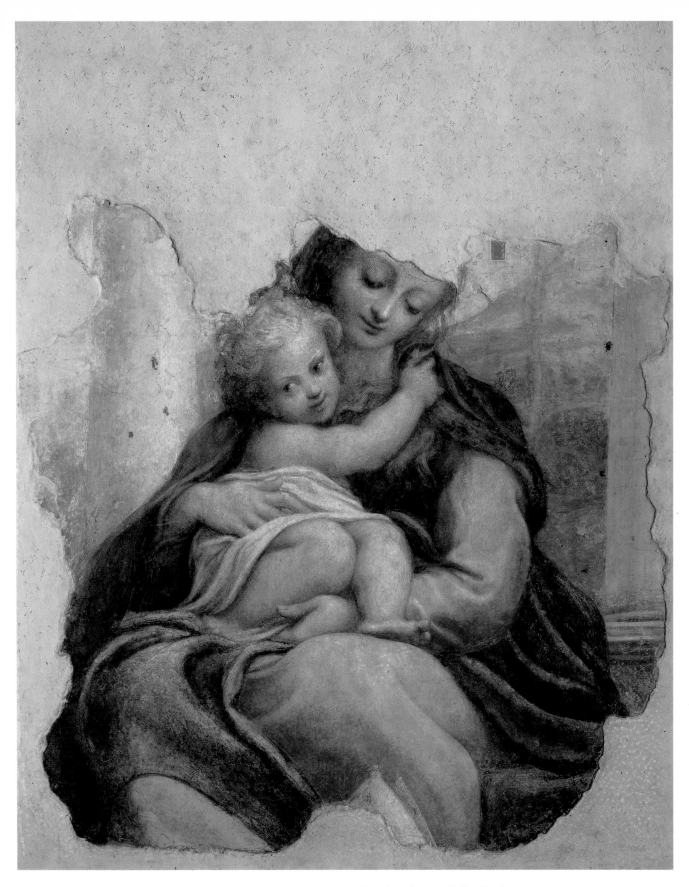

42. *Annunciation*
115x157 cm
Parma, Galleria Nazionale

43. *Madonna della Scala*
196x141,8 cm
Parma, Galleria Nazionale

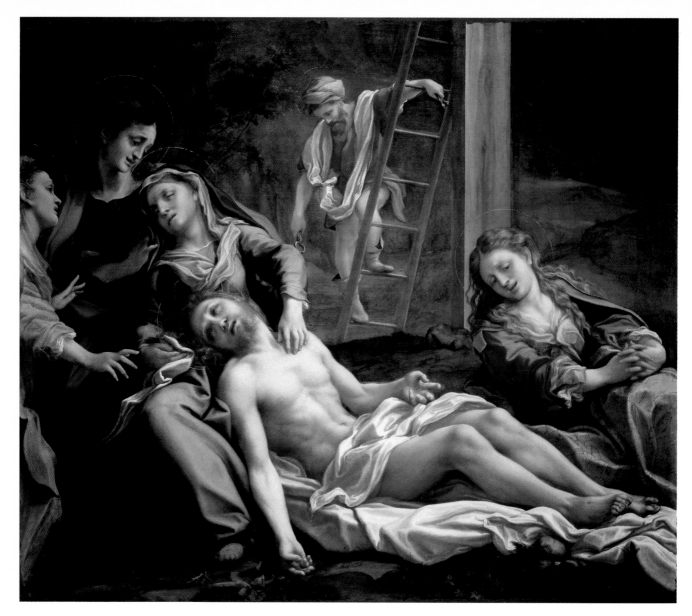

crowded into the foreground, onto the proscenium it could be said, leaving free a large portion of the scene that is dominated by the diagonals of the cross and of the ladder from which Nicodemus descends. In our view, the gestures of the figures, so dramatically expressive, are derived from those *Lamentations* in terracotta so common in Emilia. These theatrical images, turning entirely on a strict investigation and observation of faces, bodies, and attitudes, on a freedom that comes from a "living use" of sculpture and that takes its inspiration — and bestows it in return — from Veneto-Ferrarese painting, from the work of Tura, Cossa, Ercole de' Roberti, Mantegna, and Bellini. There is a difference between the techniques of molding and painting, but it was to that culture that Correggio paid attention, and from that culture that he drew his new grammar of rhetorical gesture, of movement, and of careful handling of the expressions and effects that feeling produces in the faces and in the limbs of his figures. It is a unanimous sorrow that is expressed around the prostrate, almost wooden body of Christ, rendered still more ethereal by the contrast with

44. Deposition
158,5x184,3 cm
Parma, Galleria Nazionale

45. Martyrdom of Four Saints
160x185 cm
Parma, Galleria Nazionale

the white sheet. This work set an unforgettable example for the whole of the Bolognese and Lombard culture of the Counter Reformation and for realistic seventeenth-century painting. To an even greater extent, it served as the first true model, one could say anticipation, of the emphasis and dynamism of Baroque composition.

The same characteristics are to be found in the *Martyrdom of Four Saints*, where the saber cuts and other wounds inflicted with violence and an exaggerated sense of movement leave on the faces of the martyred saints

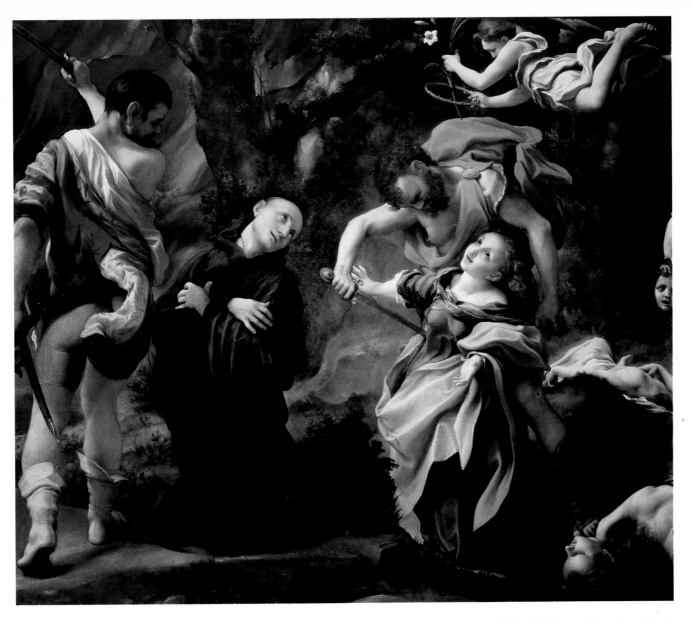

the marks of restrained pain, of ecstasy, and of grace. The site of the martyrdom is worthy of separate discussion: a rocky gorge with parched and withered, almost dessicated vegetation, contrasted by an unreal sky of jasper, almost a backdrop, with the tempera laid on in dense, opaque brush strokes.

The *Ecce Homo* in the National Gallery of London should be dated to around 1525. It has a number of elements that closely resemble those of the two previous pictures, including the shape of the figures and the sorrowful abandonment of the Virgin, supported by a compassionate female figure: characteristics that, quite apart from the forms, express a sense of absorption, producing an air of melancholy and deep emotion. It is from this period that date a series of masterpieces that show the artist to have achieved a perfect balance between sense and sentiment, between form and thought, and between suppleness of line and color and skill in composition.

An example of this is the *Madonna worshipping the Child* in the Uffizi, donated by the Duke of Modena, Fran-

cis I, in 1617 to Cosimo II de' Medici, who placed it in the celebrated tribune. In this picture the artist does not renounce references to Raphael and to Veneto-Ferrarese painting in the landscape, which has something wonderful, silent, and unsullied about it. It extends beyond the abandoned hut, in ruins, and beyond the tranquil flight of steps covered with wild grass. In this way an effect of contrast is achieved between the poor backdrop and the richness of the Virgin's attitude. The latter is engrossed, almost entranced by the liveliness of the Child she has laid on the straw, although not before having placed the hem of her mantle underneath him in a gesture of tenderness. Small touches that make this a great painting, with its accuracy of execution, its poetical representation of the Virgin's loving attentions, and its precise description of even the tiniest detail.

It is enough to look at the interlacing of the tree trunks in the manger, the majestic soaring of the column in that modest refuge, and the folds of the drapery and the tenderness of the pose. An almost too perfect picture that makes use of the schemes of Raphael's madonnas, but

43

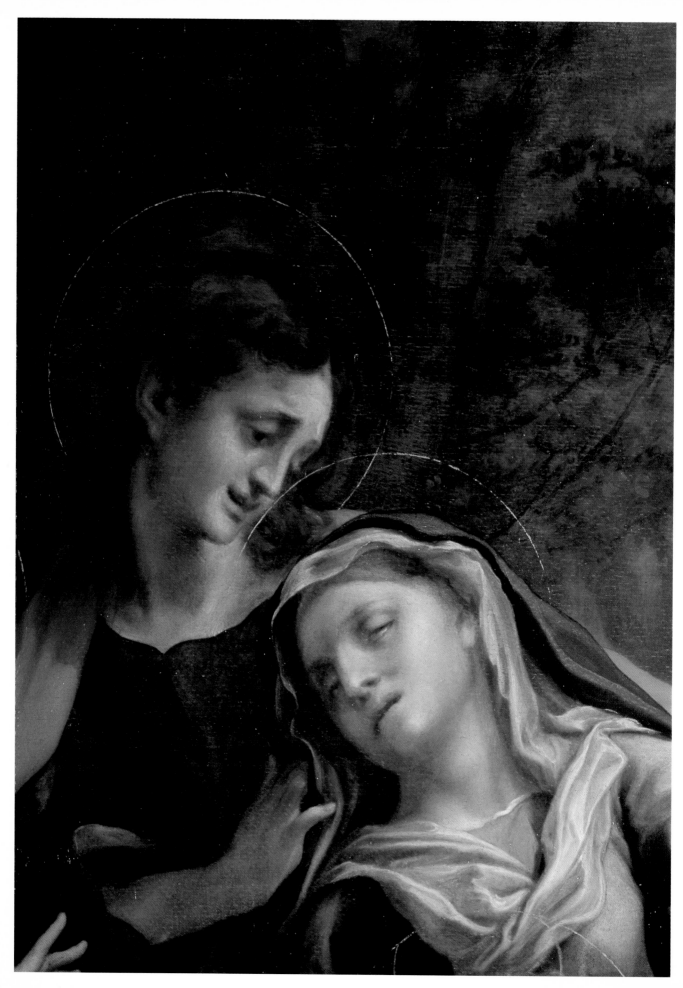

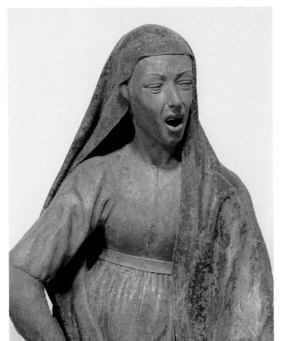

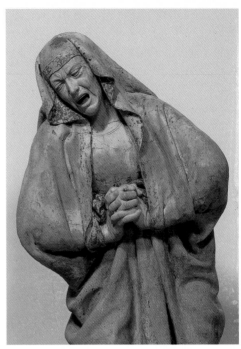

46, 49. *Deposition, details*
Parma, Galleria Nazionale

47, 48. *Niccolò dell'Arca Pietà, details Bologna, Church of Santa Maria della Vita*

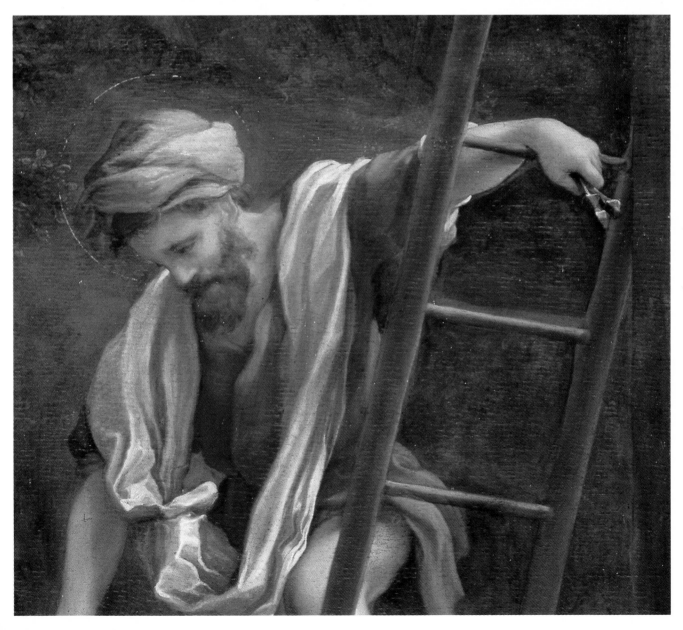

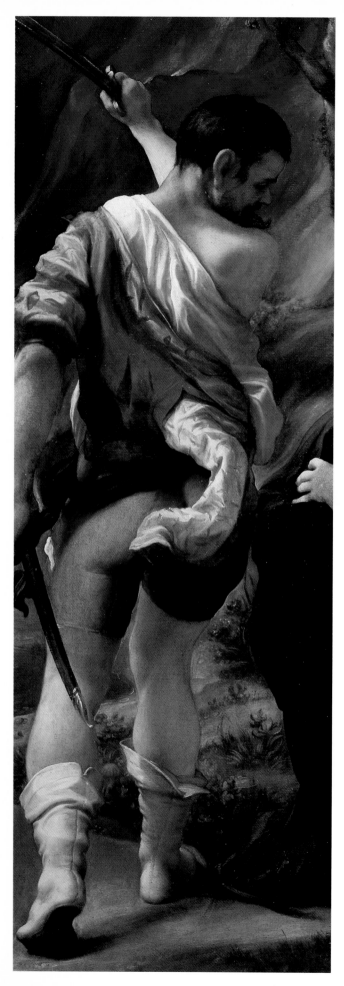

that oozes with humanity, with maternal love.

The same characteristics can be found in the *Madonna del Latte* (Madonna of the Milk) in Budapest, in which the Virgin, with an affectionate gaze, watches the distraction of her son as he is attracted by the fruit offered to him by the young St John, just as she is giving him her breast. It is a very tender and reassuring composition in its presentation of the intimate relationship between mother and son, through the interlacing of gestures, the contact of their skin, the light veils that cover their bodies, and the pattern of light and shade that harmonizes their forms and emphasizes their tenderness.

The *Madonna della Cesta* (Madonna of the Basket), in the National Gallery of London, can be dated to 1525-26. Despite the similarity of subject, Correggio renews the composition by dividing up the scene with a diagonal: on one side is the Madonna, restraining the lively movements of the Child with his disheveled clothing and naturally exhibited nudity, and the basket containing sewing things; on the other St Joseph is at work, as if in the background, amidst the ruins of one of the many small huts of the Po Valley that the artist would have seen on his journeys between Parma and Mantua, Modena, and Correggio.

The Madonna and Child feature again in the arched *San Sebastiano Altarpiece*, now in the Gemäldegalerie of Dresden, where the figures stand, amidst a glory of angels moving bizarrely over the clouds, above St Sebastian, St Gimignano, and St Rock. In all probability, the large picture was painted in 1525-26, for the Modenese confraternity of the same name. The classical equilibrium of the composition based on Raphaelesque stylistic elements is still there, even though there are signs of a Manneristic distraction and, even more, of a push ahead that was to influence Michelangelo Anselmi, Bedoli, and, to an even greater extent, Schedoni and Lanfranco, who recognized in this work a great lesson for the years to come as well.

In the *Wedding of Saint Catherine* in the Louvre, dating from 1525-26, the artist proposes two levels of interpretation: the one in the foreground, still pervaded by refined solutions in the poses, the clothing, the profiles, the soft hair styles, and the smile of St Sebastian, which serves as a link with his martyrdom, set in the second level of the painting, among the trees in the distance. This landscape conforms to the conventions of the Renaissance and has, perhaps for the first time, a narrative intent.

The *Agony in the Garden*, in the Victoria and Albert Museum in London, is generally dated to 1526-28. It is a small and intense painting that interrupts the series of pictures devoted to the Virgin, but without breaking with their masterly intimism and sense of inner dialogue, which does not disappear even when the painter is faced with the need to tackle such a devotionally demanding religious theme.

46

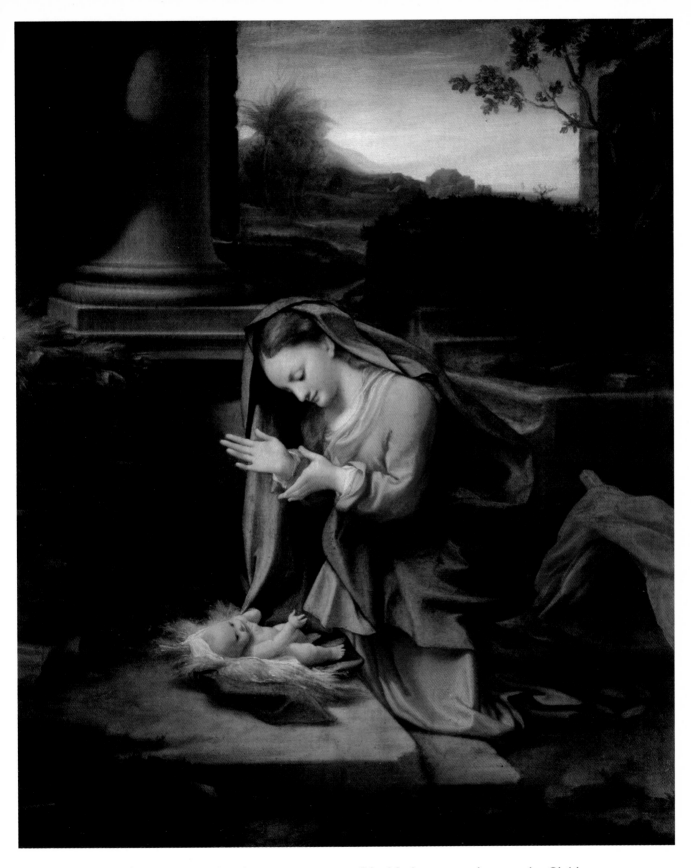

50. *Martyrdom of Four Saints, detail*
Parma, Galleria Nazionale

51. *Madonna worshipping the Child*
81x67 cm
Florence, Uffizi

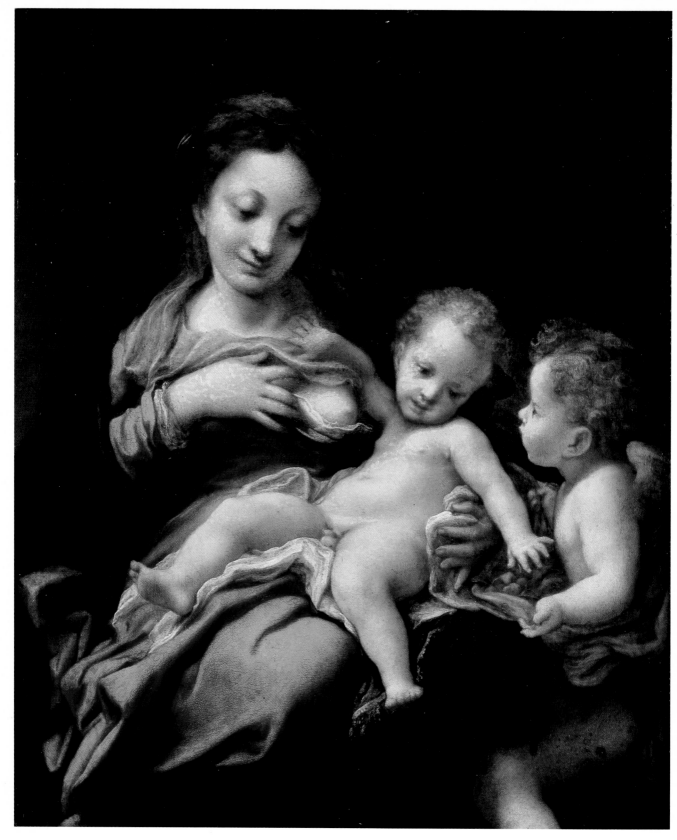

52. Madonna del Latte
68,5x57 cm
Budapest, Szépmüvészeti Múzeum

53. Madonna della Cesta
34x25 cm
London, National Gallery

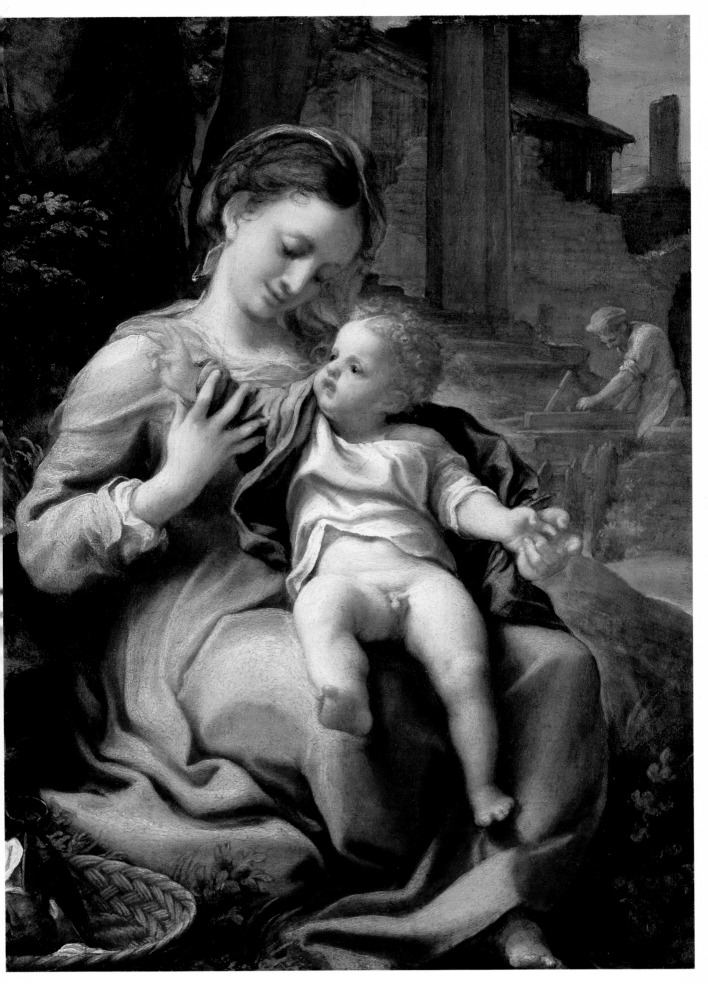

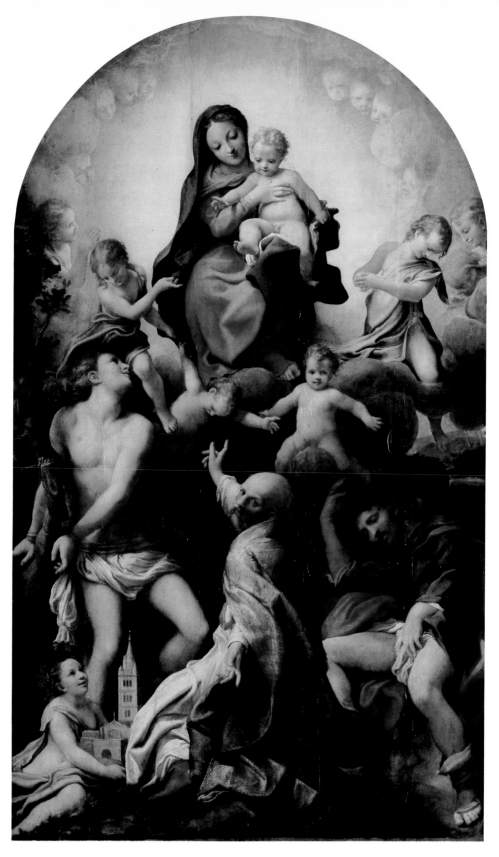

54. *Madonna with Saint Sebastian*
265x161 cm
Dresden, Gemäldegalerie

55. *Wedding of Saint Catherine*
105x102 cm
Paris, Louvre

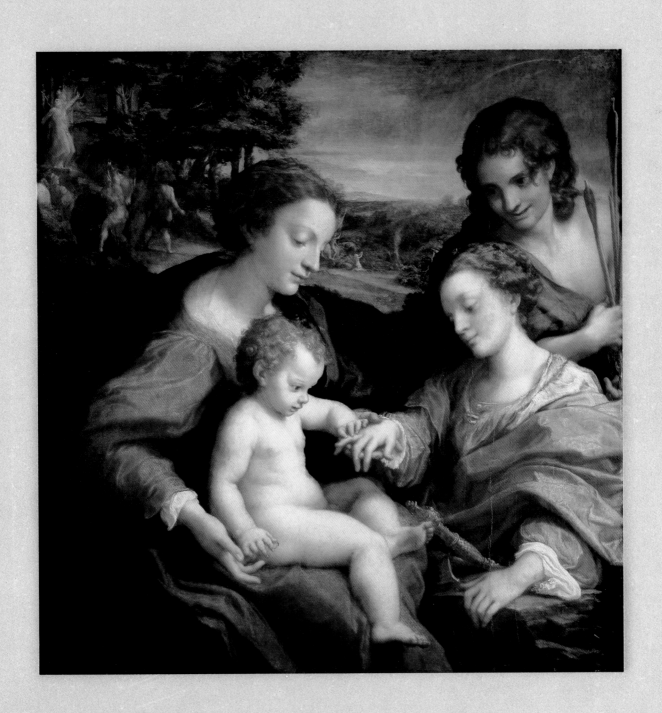

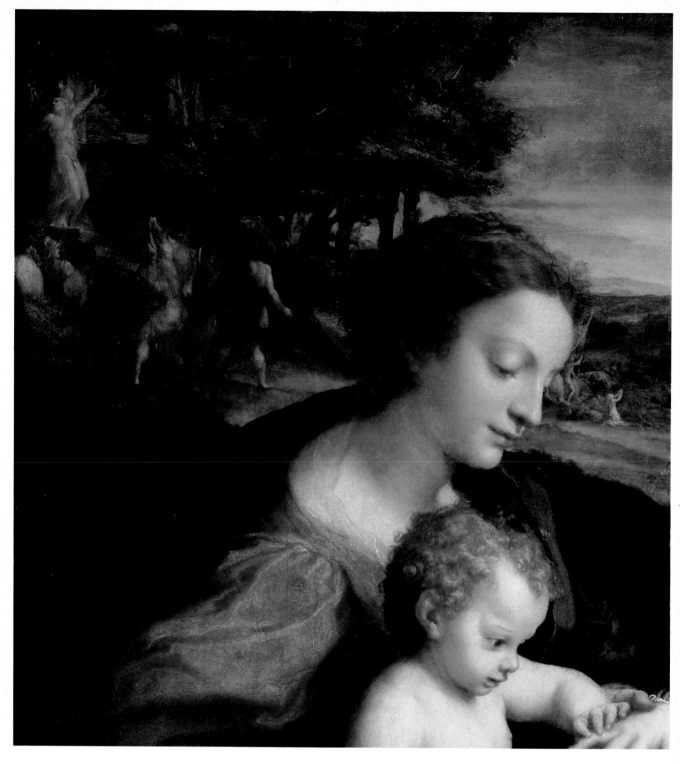

56, 57. Wedding of Saint Catherine, details
Paris, Louvre

The Dome of the Cathedral

A new chapter opens, between 1526 and 1530, with the major undertaking of the dome of Parma cathedral, devoted to the theme of the *Assumption*. It is a subject that appears to respond, in some ways, to the crisis in which the curia of Parma found itself, and to the danger inherent in Lutheran protest, as well as to the bitter differences of opinion that were emerging within Catholic orthodoxy. Correggio had received the commission in November 1522, when he was still fully engaged in the work on San Giovanni. The agreed remuneration was one thousand one hundred gold scudi. The board of trustees agreed to "give him ready-made scaffolds and the slaked lime for plastering and the walls *in salbato*." The artist requested a "large closed room or chapel to make the designs." Once the practical aspects had been settled, what remained was the elaboration of the theme, the way in which it was to be treated. The dome, set on an octagonal drum, would hinge on the location of Our Lady of the Assumption, to be set in an axial position with respect to the nave. This is a repetition of the scheme used in San Giovanni, where the Saint was placed in line with the choir. Above the marble molding are set the gigantic standing figures of the Apostles, represented in the act of climbing an imaginary stairway that leads them

to the tomb of the Virgin, symbolized by the church itself, seen as a link between earth and heaven. Behind the Apostles rises a balcony interrupted by eight large *oculi*. Young men are seated astride it in various poses, holding candelabra, paterae, boats, and shrubs. This still represents the terrestrial world, and over it hangs, after a stretch of sky, a glorious and endless row of angels bearing dulcimers, viols, violins, and flutes. These perform a wild and frenzied dance that contrasts with the immobility of the onlooking saints, accompanied by Christ, in flight like an angel, having descended from heaven to be present at the triumph of his mother. In the pendentives, four large shells enclose the patron saints of the city: St John the Baptist, St Hilary, St Thomas, and St Bernard, linked together by a bas-relief frieze, with putti set amidst plant volutes and serpents that are framed by pendants of greenery and ripe fruit.

The illusion of perspective is one of the most effective ever achieved, and is ideally suited to the theatricality of the ceremonies staged by the church on special occasions. In spite of its complete novelty, it would be impossible to explain this solution without invoking the influence of Roman culture on the one hand, and, to an even greater extent, that of Veneto-Lombard culture on the other, and in particular the names of the late Bellini — the master of Giorgione — and of Lotto and Titian. The fact is, Correggio showed himself here to be poised between Neoplatonic idealism and a move away from classicism in the direction of an intense naturalism and a new modernity that consisted in asserting the possibility of expressing not only the tangible in painting, but also the intangible. And so the light and the heavenly bodies are made visible, but only through a light, airy color, free from geometrical markings. This paradise of Correggio's has nothing plain about it, but is incredibly soft: the divinity is at once light and matter, and set high above among the clouds that break through in an aerial scene of great effectiveness. It is this that renders Allegri's work so ineffable and elusive. He avoids any attempt to tell a story, which would have required divisions of the scene, and takes direct hold of the event. Correggio seizes on the culmination of the representation, the salient moment, without any need for prologue or appendix, and in the same way involves all the bystanders. In this he shows himself once again to be the unique founder and anticipator of the Baroque style.

Moreover, notwithstanding an extensive exploration that has embraced vast sectors of the local culture and that of Italy as a whole, no one has yet succeeded in coming up with a convincing hypothesis that would match and support the elevated heights of the thinking that underpins his painting. It is not enough to cite the Tuscans and the Venetians, to refer to Leonardo and Giorgione,

58. 'Sinopia' with a foreshortened woman's face
Parma, Galleria Nazionale (formerly on the dome of the cathedral)

59. Assumption of the Virgin, cupola
Parma, Duomo

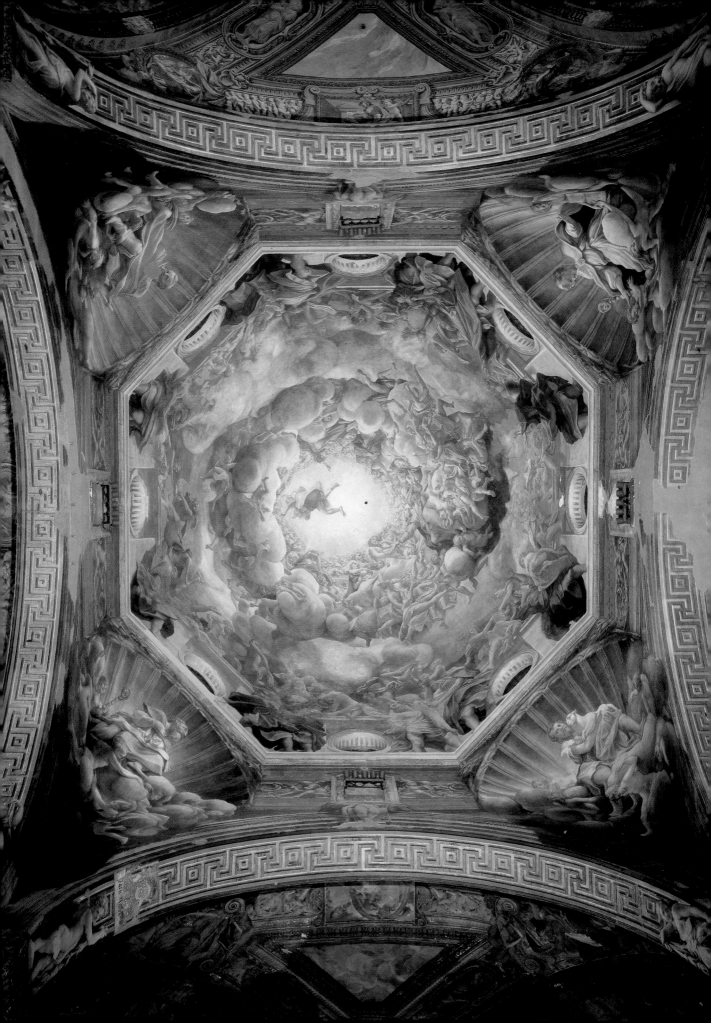

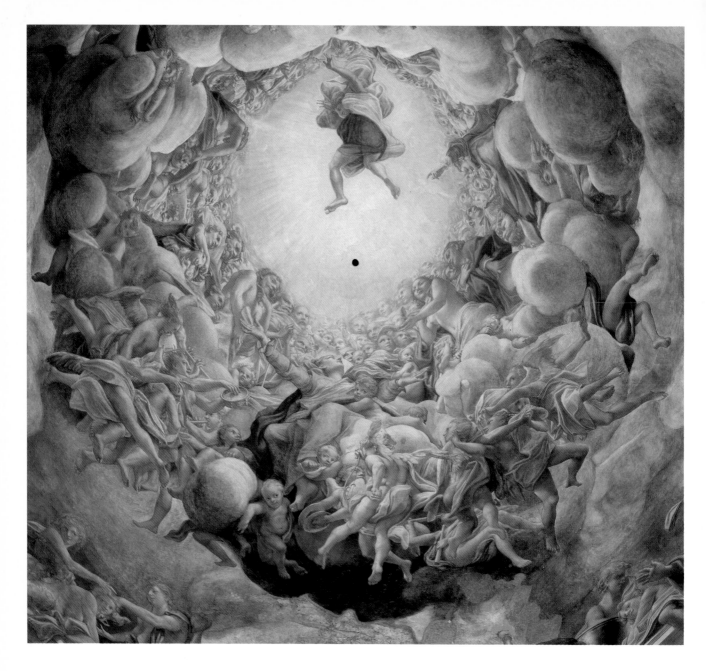

Raphael and Michelangelo, in order to find some matrix that would explain his art. The artist reveals here, or confirms, a line of his own — level, rounded, convex, free from sharp corners, from any sort of geometrical subdivision — that shows an uncontested, emphatic, and direct ascent through the three domes of Parma. They constitute an unfolding of increasingly complex proposals and the achievement of a complete spiritual narration.

The dome of the cathedral seems to be the fruit of imagination and dream, and Correggio gives substance to a heavenly vision, utilizing a vertical discourse that cunningly exploits the contrast between the concreteness of the church and the height of the dome. It allows him to introduce an ethereal world, that of light, air, flight, and cloud, an unstable formation in the sky, without outlines and without definite color, even though it is sustained by the force of a matter in which each figure that draws close to it is illuminated and vanishes.

60. Assumption of the Virgin, detail of the cupola Parma, Duomo

61. Assumption of the Virgin, detail with the apostles Parma, Duomo

The clouds are the principle of construction of Correggio's domes: their soft and elusive masses, with their hazy and unstable outlines, linked to the nature of the winds, the light, and the weather, can be combined in a thousand ways.

Michelangelo's figures in the Sistine Chapel are firmly ensconced on stone seats and surrounded by an imposing system of moldings, arches, and pilasters that contain a further subdivision into round and square panels. Correggio rejects all this and by splitting his space into three levels (earthly, intermediate, and celestial) transcends the convention hitherto adopted by his predecessors. His vision tears the veil of possible certainties and his choice goes beyond the level of common experience, introducing a spiral-shaped vision that is based on a system of ascent and descent.

In their investigation of his system of composition, critics have rightly seen the cloud — an element which is also much used in both dramatic and sacred representations and as a constructive base for the empyrean of the gods as well — as the obligatory accompaniment, as the driving force of the ecstasy, of the ascension, of the Assumption, of transport and of transit.

Correggio's clouds are simultaneously an indispensable accessory for the *mise-en-scène*, an attribute for the characters of his drama, a device for freeing the space of division, and a trick for deceiving the eye and the heart of the observer, and are at one and the same time material and immaterial. They are, in fact, solid enough to support powerful bodies subject to the law of gravity, and yet so airy and insubstantial as to permit a myriad of putti and cherubs to make their home in them, to dive through their vapors, to emerge out of them as if from water. The sky opens up and we are offered a glimpse of the infinite.

It is no accident that Annibale Carracci should have expressed such admiration for Correggio's "sublime machine" and that Titian, when passing through Parma in the retinue of Charles V, should have silenced, without compunction, the grumbles of the canons of the time who, on the unveiling of the work, had expressed their dissatisfaction. He did so with the celebrated words: "turn it [the dome] upside down and fill it with gold... that is its price." Nor is it a surprise that Mengs asserted him to be unrivalled in chiaroscuro and in the aerial perspective, and that Stendhal, who was accustomed to the style of the eighteenth century, "was moved to tears" by the vision of such a masterly grasp of the art of painting.

This dome marked the beginning of a total renewal of perspective, an overturning of the concept of space. It was the first step on the road that was to lead to the vision of the Baroque, anticipating by almost a century the works in Rome, for which it served as an explicit model.

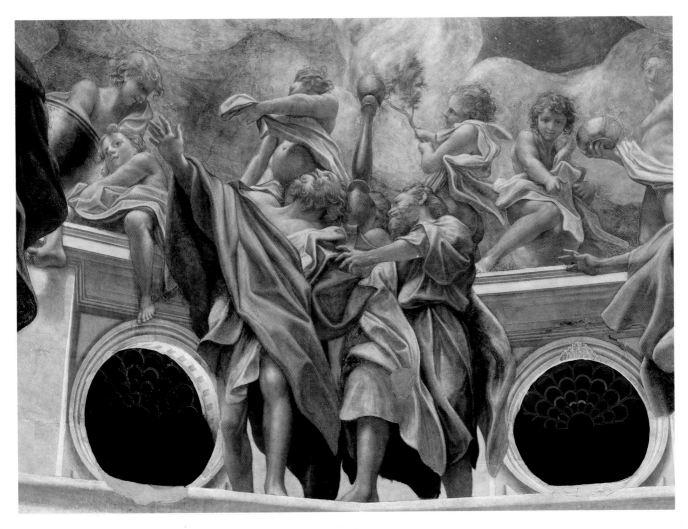

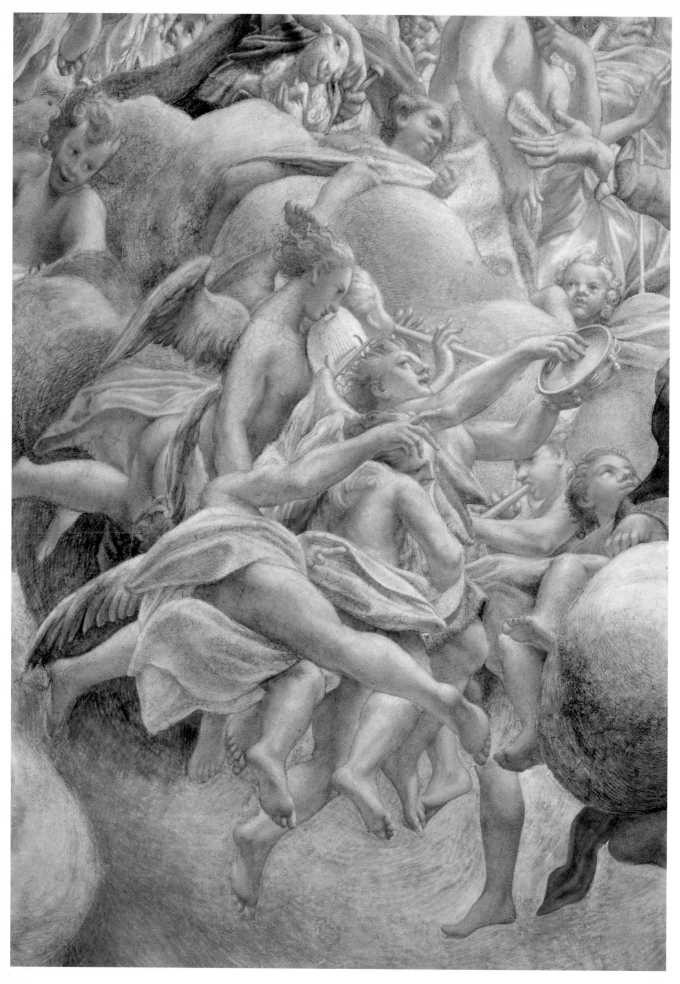

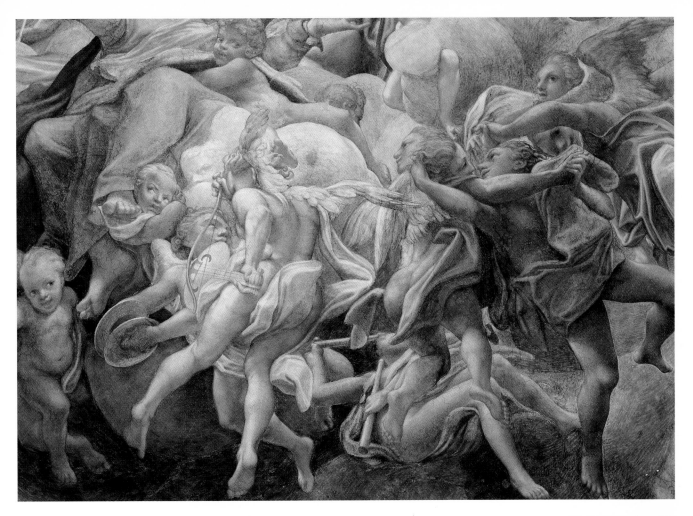

62, 63. Assumption of the Virgin, details with angels bearing musical instruments Parma, Duomo

64. Assumption of the Virgin, detail with the Assumption Parma, Duomo

65, 66. Assumption of the Virgin, details with Eve, angels, and putti Parma, Duomo

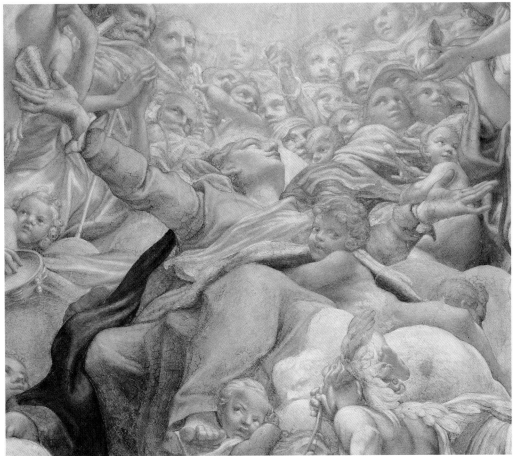

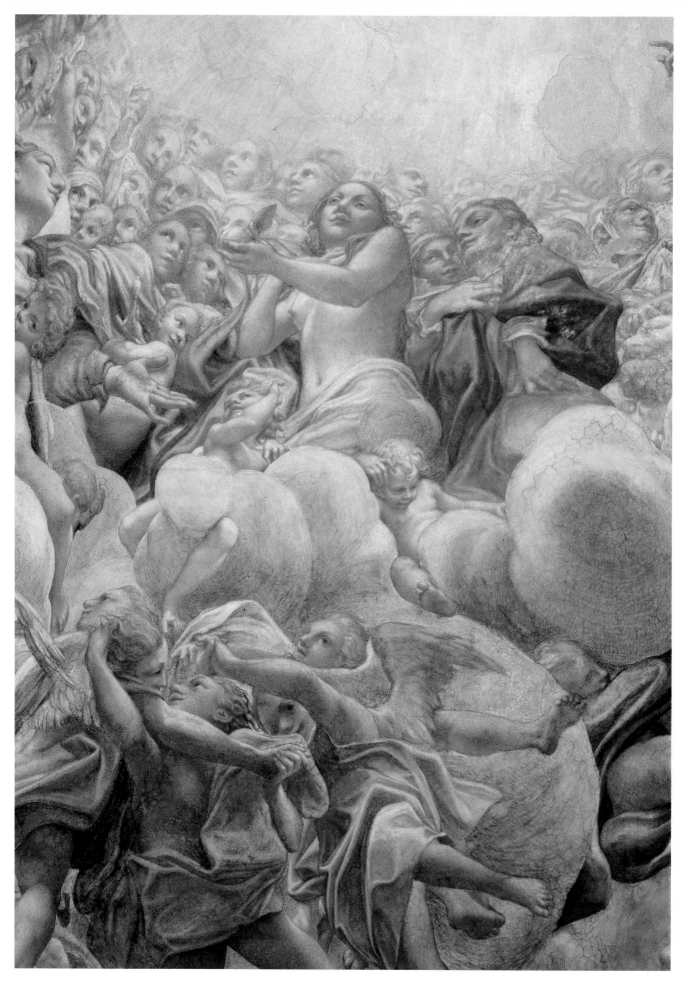

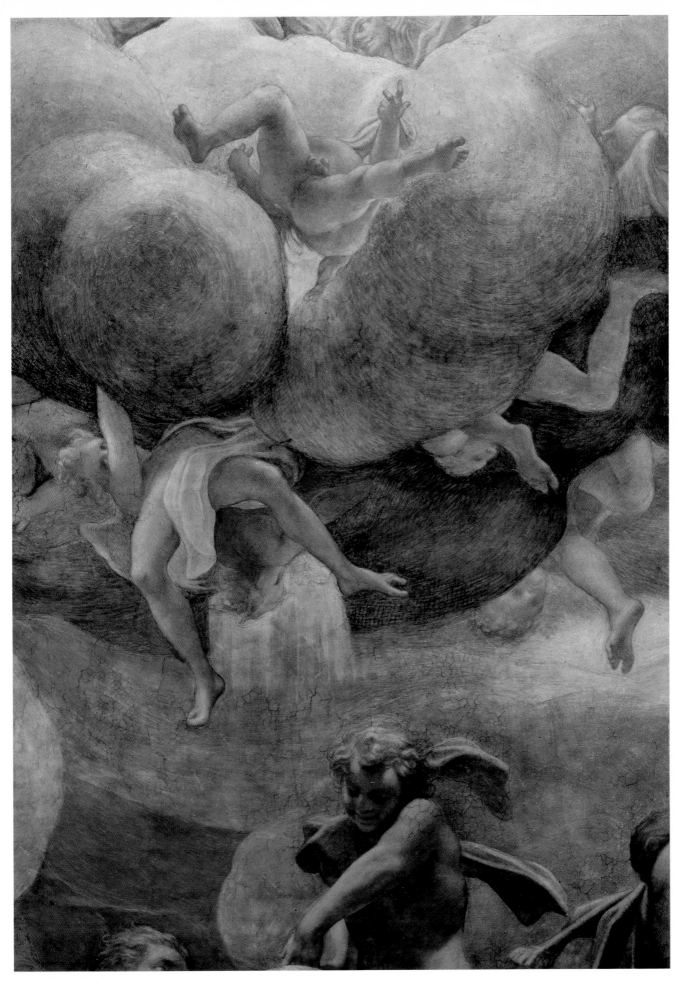

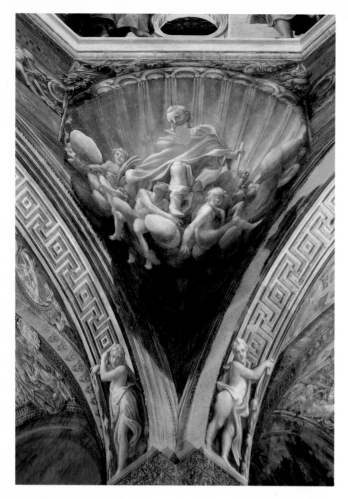

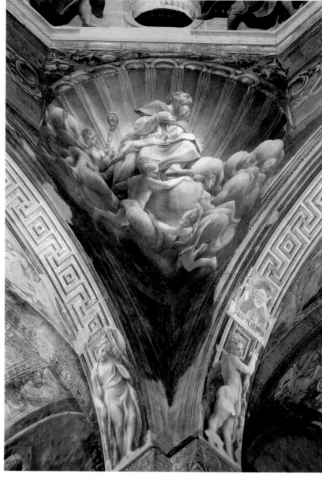

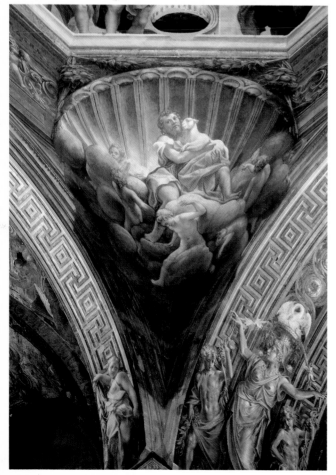

67-69. *Pendentives depicting Saint Thomas (or Saint Joseph), Saint Bernard, and Saint John*
Parma, Duomo

70. *Partial view of the cupola with (in the foreground) the pendentive depicting Saint Hilary*
Parma, Duomo

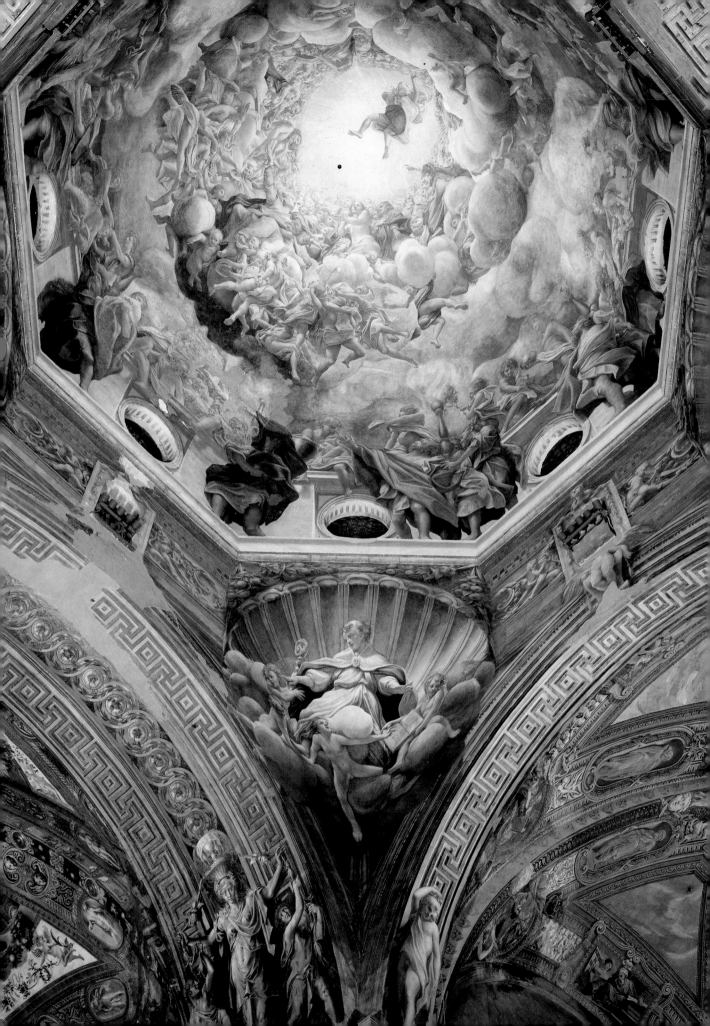

The Great Altarpieces and the Profane Pictures

At the same time as he was carrying out the assignment in the dome of the cathedral, Correggio painted some of the most interesting and complex paintings of his entire career, commencing with the panel portraying the *Madonna with Saint Jerome*, now in the Galleria Nazionale of Parma. This was commissioned from the artist in 1523, by Briseide Colla, in commemoration of the death of her husband Orazio Bergonzi. It was intended for their chapel in the church of Sant'Antonio, where it was placed in 1528. The painting earned Allegri the sum of four hundred imperial pounds, together with two cartloads of faggots, a few bushels of wheat, and a pig.

The large piece of red cloth placed over the fronds bestows on this Sacra Conversazione the quality of an unveiling, a revelation that introduces the figures arranged in a semicircle in the foreground as well as the extraordinary stretch of landscape in the background. The figures are closely bound together by an intertwining of gestures and glances that gives the painting an indissolubly unitary character. The St Jerome with his back turned introduces the discourse and passes the action to the angel. The latter is turning the pages of a sacred text to show them to the Child who, in turn, is caressing the blond hair of Mary Magdalen. She, in a wonderful gesture, is supporting his foot and rearranging his clothes. The Madonna occupies the focal point of the composition and gazes in absorption, with her eyelids lowered and the hint of a tender smile, at the movements of her companions. Although the painting is by now an expression of his own, absolutely independent vision, one cannot ignore the refined presence of features taken from the work of Leonardo, Raphael, and Titian. However these are fused into that brilliant invention that Correggio adjusts and amalgamates with his own special palette, with that superior grace of his that places it among the heights of Italian painting during the Renaissance.

But the artist, having established a reputation as the painter of the Madonna, of clouds, and of heavenly glory, also ventured into the field of profane representation. He did this at the instigation of the Duke of Mantua, Federico II Gonzaga, who first ordered from him the *Education of Cupid*, now in the National Gallery in London, and *Venus and Cupid with a Satyr*, now in the Louvre. Some critics assign these to 1523-25, but others place them more convincingly around 1528. In the first Cupid stands between Venus and Mercury, who reveals to him the contents of a message of love. In these works, Correggio inaugurates a fullness in his representation of the human body, of flesh and nudity. This is basically a new feature in the culture of the Po Valley and one which finds parallels in the daring paintings of Giulio Romano in Mantua and in the new, "erotic" genre that was emerging at the courts of the region.

But Correggio's painting also appears to be a continuation and development of Leonardo's investigations into nature and the human body, as well as into the mystery of its existence and creation, into its full, inviting form, and into its future, the changes that are to come.

In the painting in the Louvre, Venus and Cupid are lying asleep in complementary poses: a repose that is disturbed by Jupiter, in the guise of a satyr. With a mischievous expression, he lifts the cloth that covers Antiope to enjoy the sight of her naked body. In both paintings it is the sensual nudity of the female bodies, of their rotundities, that reveals to us a non-traditional, quite different Correggio, while the wooded landscapes appear to be a development, a logical maturation of his interpretation of nature, softer and dreamier than in the sacred subjects of his youth.

For the family chapel of Alberto Pratoneri, in the church of San Prospero in Reggio Emilia, Correggio painted The *Adoration of the Shepherds* or *The Night*, now in Dresden. This was commissioned in October 1522 and completed at the end of the decade. It has been described as the first monumental nocturnal scene in European painting, and it is an ideal companion to the *Madonna with Saint Jerome*, also known as *The Day*, painted only a few years earlier for another private chapel. The artist, following the trail blazed by a number of celebrated works by Titian, interprets a scene that is fully *à la chandelle* and produces an outstanding result. The light appears simultaneously to bathe and to emerge from the Child, who is lying on a rough pallet, only to soften on the face of the Virgin, tenderly rapt in a maternal embrace. They are surrounded by the fluid gestures of the shepherds and of St Joseph, who is holding back the donkey, and by the kicking legs of the angels transported by the cloud that spreads hazily through the picture.

Although attenuated by the dim nocturnal light that tones down all the shades, the painting is not lacking in color and the chiaroscuro spreads over and softens every form, bringing out their rotundities and caressing those leaves that are reminiscent of Leonardo and of Veneto-Ferrarese painting. It is a picture that points the way toward the future Lombard investigation of luministic effects, and was used as a model by such painters as Procaccini, Reni, and Domenichino, and even later on, by Barocci and Maratta.

Correggio's penultimate great altarpiece can be con-

71. Madonna with Saint Jerome (or "The Day")
205,7x141 cm
Parma, Galleria Nazionale

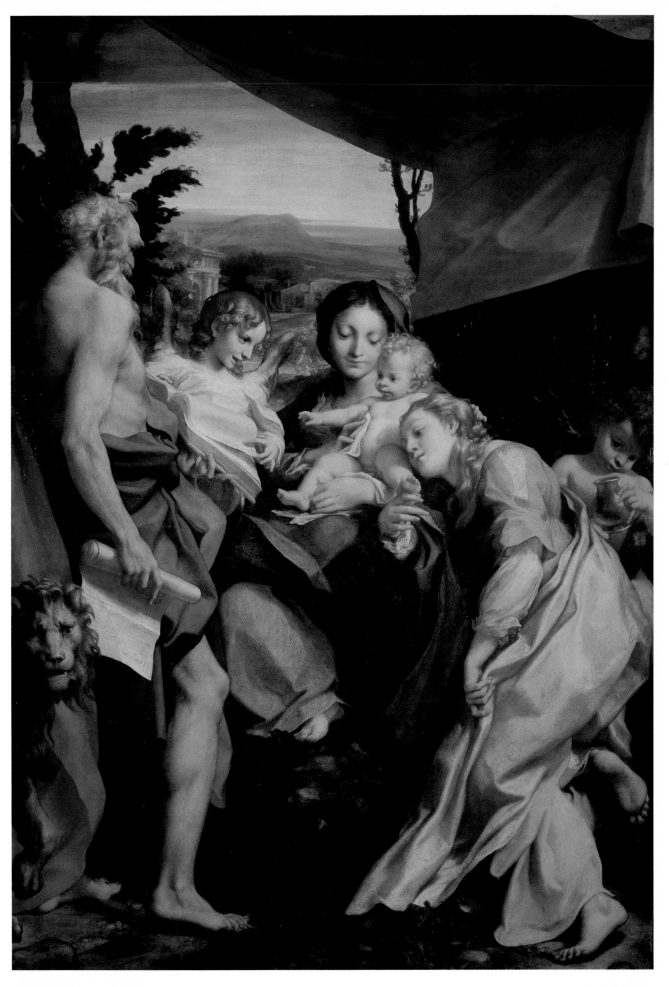

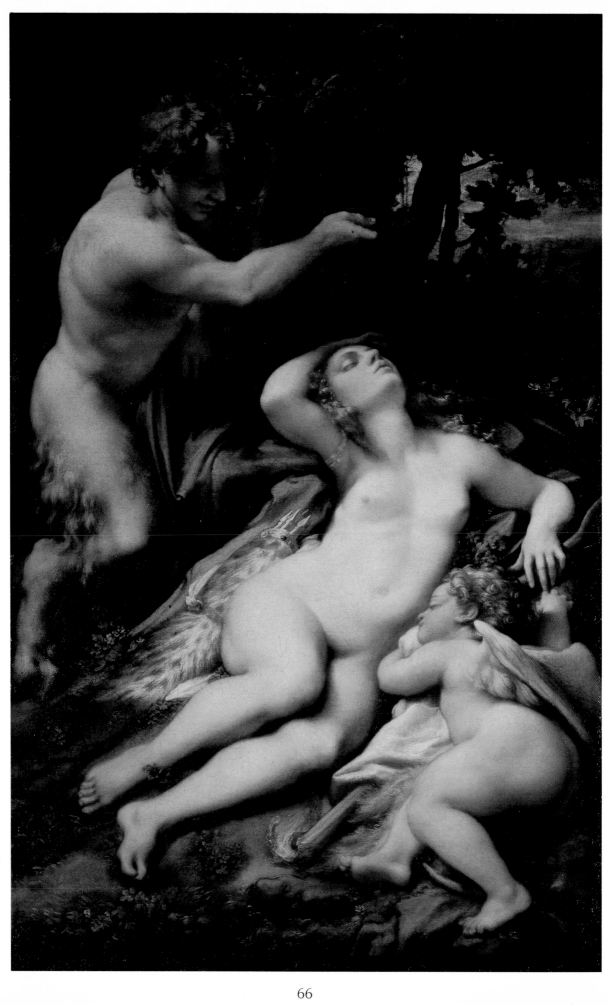

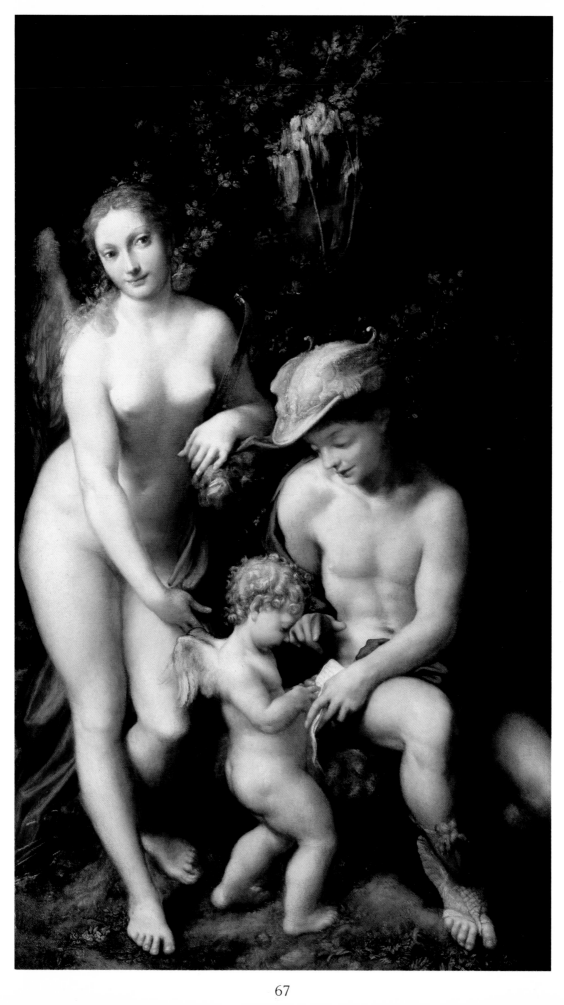

sidered the *Madonna della Scodella*, now in Parma and painted for the church of San Sepolcro.

As in the earlier *Madonna* in the Uffizi, this picture illustrates an episode taken from an apocryphal gospel, which relates how, on the holy family's return journey from Egypt, a palm tree had bowed down to offer the tired travelers its dates. The picture's traditional name derives from the *scodella*, or bowl, in which the Virgin collects the water poured by the angel to quench the Child's thirst.

The critics have dated the commission for the painting to around 1523, but it is likely that it was not completed until 1530, as is indicated by the inscription and date written in capital letters in the bottom part of its original and opulent frame. The latter was, it seems, made by Marcantonio Zucchi to Correggio's own design. The flight of angels, clinging to the clouds, which so closely resembles the solutions adopted in the dome of the cathedral and in *The Night*, is contrasted by the harmonious and static connection between the diagonal poses of the figures, creating a continuity that is reminiscent of the *Madonna with Saint Jerome*.

Once again the influence of Leonardo can still be seen in the landscape and in the smile and attitude of the Virgin, and that of Raphael in the brilliant tints of the violets, the whites, and the orange-yellows. This is a range of colors that Schedoni would make use of later on, although with different intentions, more suited to the taste of the early seventeenth century.

This work was followed by the *Madonna with Saint George*, now in the Gemäldegalerie in Dresden. Correggio painted this altarpiece for the oratory of the confraternity of San Pietro Martire in Modena a few years prior to his death, between 1530 and 1532, the date that Lancillotto says it was placed on the altar. The Madonna and Child still form the hub of the composition. Around them are set Saint Gimignano who is holding a model of the city of Modena, of which he is the patron, along with St John the Baptist, St Peter the Martyr, patron of the confraternity, and St George with his foot on the dragon's head.

The work is so complex that, while it fits into Correggio's tradition, it stands as a compendium, as a "summa" of all his earlier experiments. Each figure is assigned a distinct space of its own, a pattern that is only broken down by the putti squabbling over the weapons of St George. The putto closest to the foreground has a vivacity that brings Parmigianino to mind.

Correggio does not abandon his traditional repertory; on the contrary he enriches it with the cambered apse decorated with fruits and flowers and supported by two ephebes that serve as talamones, draped and buried in festoons of flowers, and with the landscape behind the Madonna, which makes the richness of her swelling drapes stand out even more. He is still using a Mannerist back lighting, derived from Beccafumi.

This work seems to be a condensation of the whole of the artist's visual culture which, starting out from Mantegna, Costa, Francia, Giorgione, Bellini, Leonardo, and Raphael, went on to find its own highly personal expression, as well as a compendium of his favorite motifs.

But Correggio's career concludes with four other works painted for Federico II Gonzaga.

These appear to have been intended as an ideal complement to the previous pair of pictures executed for this patron, the *Education of Cupid* and *Venus and Cupid with a Satyr*.

Although Vasari claims that these paintings were intended as a gift for Charles V, on the occasion of his coronation in Bologna, it has recently been shown that they must have been part of the decoration of one of the rooms in Palazzo Te, known as the "Sala di Ovidio." This decoration had been designed by Giulio Romano and was supposed to include, according to a well-defined program, eight panels by Correggio devoted to the *Loves of Jupiter*.

Metamorphosis was, moreover, one of the dominant themes at sixteenth-century courts and some critics have made a connection between it and the reworking of Plotinus' philosophy proposed by Marsilio Ficino. Correggio shows himself to be an excellent interpreter of these themes, as was Parmigianino who in his youth, prior to his journey to Rome, had illustrated the fable of *Diana and Actaeon Turned into a Stag* for the study of Paola Gonzaga and Galeazzo Sanvitale in their residence of Fontanellato. This was a mark of the evident interest in Ovid's *Metamorphoses* and of a culture that used them to moralizing ends. The translation of the contents of these tales into images lent itself, moreover, to the transformation of the sometimes tragic and highly symbolic references of the original text into pleasant scenes. Even in these profane pictures particular importance is assumed by the uplifting and mimetic qualities of the cloud, the chief trademark of Correggio's painting. Each of the four canvases that he painted illustrates the union of God with a mortal creature; each time Jupiter appears to the desired creature in a different form.

The *Danaë*, now in the Galleria Borghese in Rome, is almost unanimously assigned by the critics to 1531-32, owing to the parallels with some of the ephebes and angels in the dome of Parma cathedral. The scene is set in an interior draped with rich and suitably folded hangings, framing a window opening onto the landscape, as if to "unveil" the union. Danaë, the daughter of Acrisius, King of Argos, and of Eurydice, had been shut up by her father in a tower with bronze doors, as it had been prophesied that she would give birth to a son who would be the cause of Acrisius' own death. But Zeus visited her in the form of a shower of gold falling from a cloud, and from their union Perseus was born. The maiden is reclining on a bed of classical design ornamented with knobs. Nearby Eros, as an intercessor between Zeus and the maiden, and representing divine desire, helps her to hold

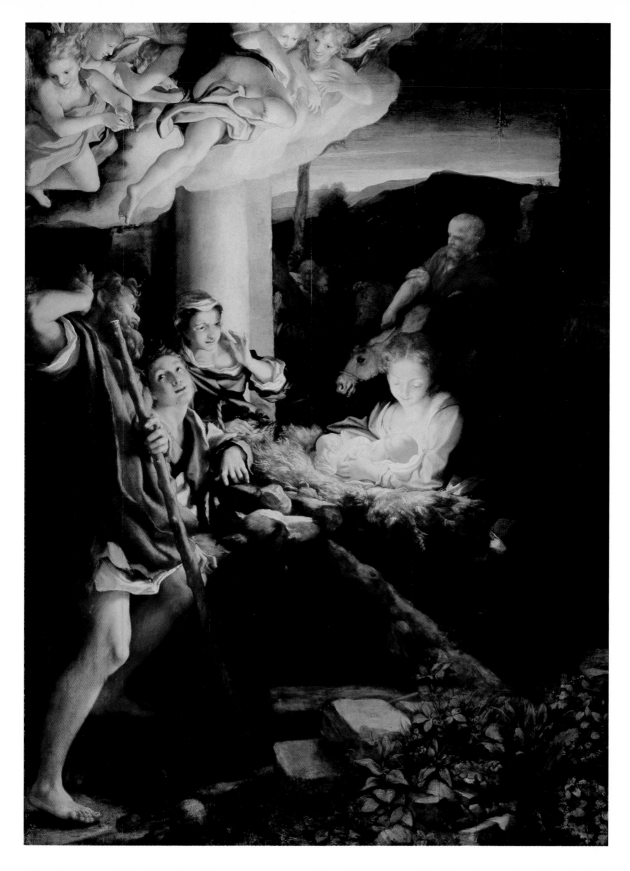

72. *Venus and Cupid with a Satyr*
188,5x125,5 cm
Paris, Louvre

74. *Adoration of the Shepherds (or "The Night")*
256,5x188 cm
Dresden, Gemäldegalerie

73. *The Education of Cupid*
155x91,5 cm
London, National Gallery

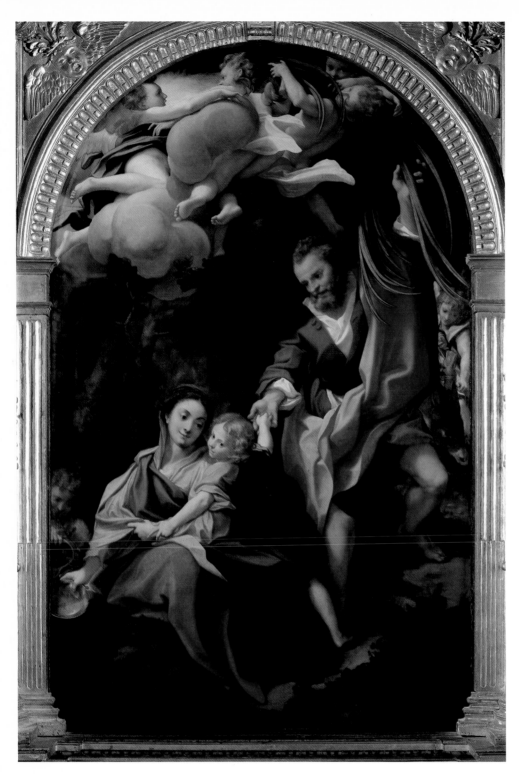

the sheet, so as not to lose the seed. At their feet two cupids, one wingless and the other winged, and intended as a contrast between "sacred love and profane love," are busy engraving a tablet with an arrow. It is a perfectly handled and balanced scene that, while reminiscent of Titian's paintings, is not free of the influence of Giulio Romano, and in particular of pictures like his *Two Lovers* in St Petersburg, painted for Federico Gonzaga in the early years of his stay in Mantua, or perhaps even in Rome, with its extremely refined virtuosity of technique and naturalistic candor. Or of his *Manners* ("Wanton Figures for Amusement of the Intellect"), a free invention from antiquity, which were mentioned by Ariosto and engraved by Marcantonio Raimondi.

Correggio's painting maintains a purity of style that never descends to the vulgarly erotic. Thus it reveals itself to be almost a prelude to some of Canova's sculptures and to certain neoclassical solutions: that sheet, rumpled so as to resemble an unmade bed — and which has been made even whiter by the recent restoration that has revealed the generally icy tones of the painting in comparison with the refined golden light usually employed by Correggio — became a model for a great deal of seventeenth- and eighteenth-century painting.

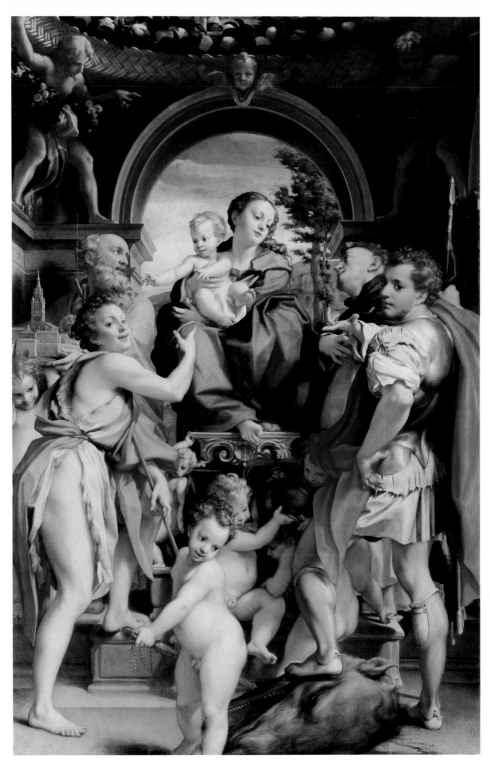

The *Leda*, now in Berlin, has led a checkered existence. It was listed in the Inventories of Philip II of Spain and then, in 1603, was purchased on behalf of Rudolph II and transferred from Madrid to Prague, where it was well able to bear comparison with the Manneristic interpretations of Spranger. In 1648 it made its way to Stockholm and then, having been acquired by the house of Orléans, taken to Paris. The Duke's son, in a frenzy of moralistic outrage, cut the canvas to pieces and destroyed the head of Leda. This was reconstructed after the work had been acquired by the painter Coypel, whose estate was put up for auction in 1752 and purchased first by the collector Pasquier and then by Frederick the Great of Prussia.

The scenery is a wooded landscape, not impenetrable as in earlier paintings, but permeated with luminous color. Leda, the daughter of Thestios, King of Aetolia, and wife of Tyndareus, King of Sparta, was impregnated by Jupiter, who had turned into a swan in order to seduce her. Out of this union were born the Dioscuri, Castor and Pollux, and Helen and Clytemnestra. The mythological account runs from the possession of the woman by the swan, which constitutes the pivot of a complete narrative sequence, up to its final flight, that bestows

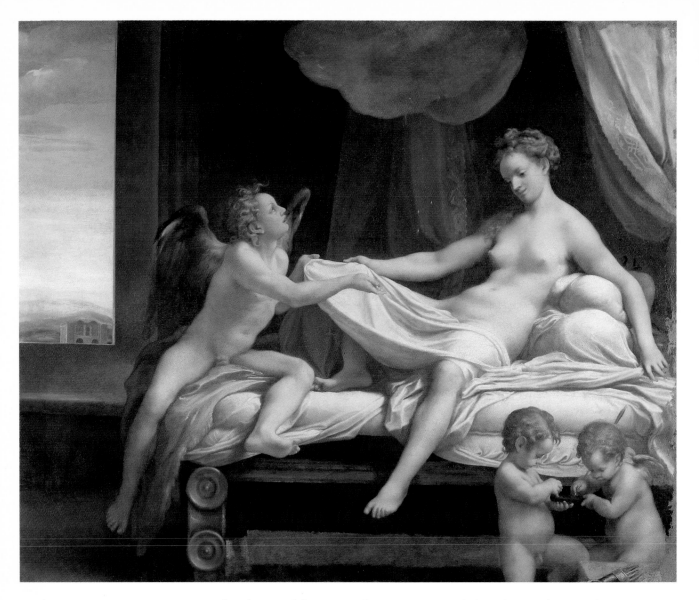

on the picture, once again, an aerial and vertical dimension. The scene is witnessed by maidservants, who first undress Leda before she enters the water, and then watch the arrival of the swan, his courting of the woman, and then the coupling.

The interpretation of the theme avoids any risk of vulgarity, concentrating on the seductiveness of the bodies and simulating the union in a playful way, even though the ripeness of the soft bodies and the amorous atmosphere that exudes from the gestures, the glances, and the poses are not lacking in the erotic sensibility with which Leonardo and Michelangelo had already experimented in paintings of the same subject.

The two vertical canvases depicting *Io* and *Ganymede*, datable to 1531-32, are now in Vienna. In the first picture, Io, daughter of Inachus, the first King of Argos, and of Melia, priestess of Hera, whose anger she aroused for having attracted the attention of Zeus, is invited by the latter, at night, in a dream, to follow him and lie with him in the meadows of Lerna. Zeus, camouflaged within a blackish cloud of constantly changing forms and in which his face and hand can be seen, undergoes new metamor-

phoses to conceal their loving from indiscreet gazes, covering them "with mist to show that divine things are concealed in the human face," as Ovid puts it in his story.

The naked priestess leans against a white sheet and her body and face convey an impression of ecstasy, of pleasure and amorous rapture, revealing a particular capacity for erotic suggestiveness. This was what was demanded by the culture of the Duke of Mantua and his court, which did not shrink from the power of painting to stir the imagination. And Correggio was a master at this stimulation of the imagination. The chiaroscuro is particularly effective, with the rocky sward covered with shrubs suggesting an abandoned place ideally suited to a secret assignation.

The *Abduction of Ganymede*, who is carried off by Zeus in the form of an eagle, has been seen as an allegorical interpretation that prefigured, in its moralizing intent, the St John the Evangelist which he painted several times in the church of the same name, and as referring to the flight of the intellect, liberated from earthly desires, toward the heaven of contemplation.

Ganymede, the son of Tros, who gave his name to

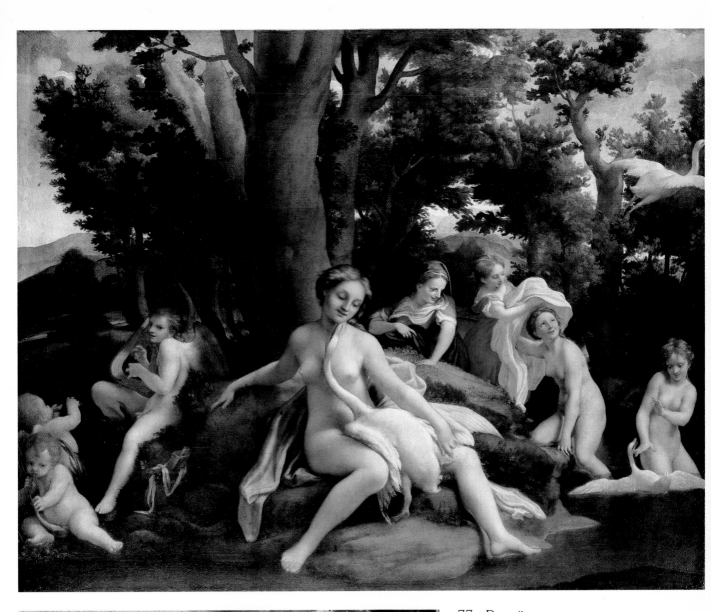

77. Danaë
161x193 cm
Roma, Galleria Borghese

78, 79. Leda
152x191 cm
Berlin, Gemäldegalerie

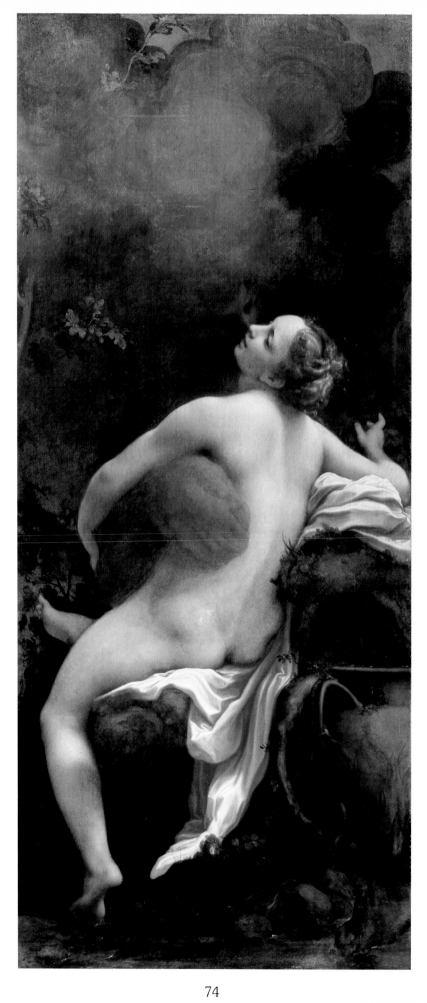

74

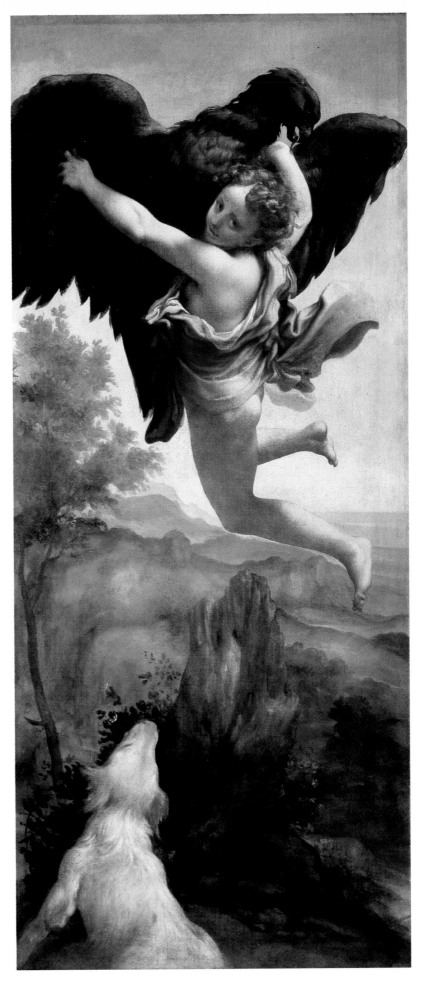

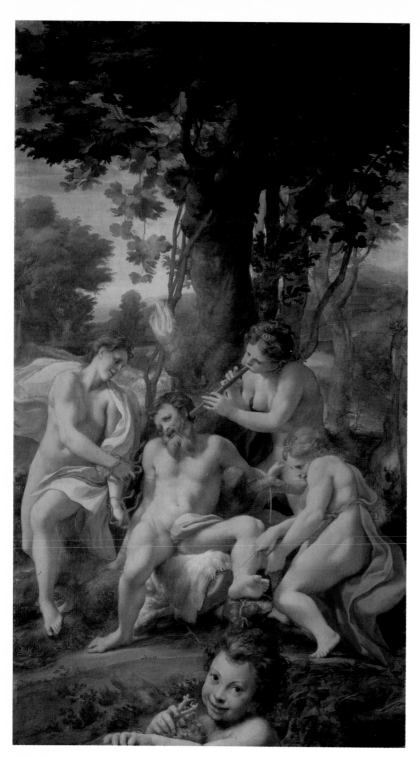

80. Io
163,5x70,5 cm
Vienna, Kunsthistorisches Museum

81. Ganymede
163,5x70,5 cm
Vienna, Kunsthistorisches Museum

82. Allegory of Vice
149x88 cm
Paris, Louvre

Troy, or of Laomedon, the father of Priam, was the most beautiful of mortal youths. Zeus chooses him as his cupbearer and, covered with eagle feathers, takes him away from his earthly games and from his dog, that looks on in fear as the abduction takes place. The landscape beneath is of an almost eighteenth-century modernity, to the point where it resembles a transparent English watercolor.

The two panels in tempera in the Louvre, depicting the *Allegory of Vice* and the *Allegory of Virtue*, date from the very last years of his life, between 1531 and 1534. They were originally in the "cabinet" of Isabella d'Este, the mother of Federico Gonzaga, in the castle of Man-

tua, where both are recorded in documents of 1542 and 1627. The scene is by now a familiar one, although with many variants, and even the structure of the composition is reminiscent of the *Leda*. The allegory is based on the use of a male figure for the first painting and a female one for the second, surrounded by a range of temptations or of virtuous practices. The iconography is extremely complex and has been interpreted in a variety of ways, as with the Camera di San Paolo. It is possible that the meanings of these paintings will never be completely revealed. This too is part of the mysterious fascination, the attraction that these works still have for us, at a distance of centuries.

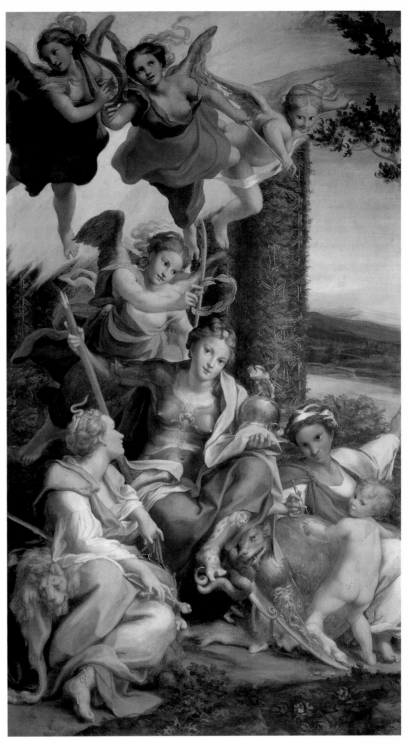

And so the artistic career of Correggio ranged, with uncertain steps, between the already mature results achieved in Mantua, Ferrara, the Veneto, and Bologna, soared to new heights under the influence of Tuscan and Roman culture, and then broadened, grew richer, and again attained an extraordinary fertility in the innovative solutions of his domes, in the altarpieces of his maturity, and in the last, profane pictures. His legacy would be taken up, over the centuries, not only by the follow-ers of the school of Parma, but also by Baroque painting and by the languid masters of the rococo. It was even to inspire some currents of nineteenth-century pre-impressionist painting in France. It was a great and profound lesson, that of the artist from Correggio and the adopted son of Parma, a lesson that was able to stimulate different schools and painters, without ever diminishing or falling victim to some of its more reductive interpretations.

Essential Bibliography

G. VASARI, *Le vite dei più eccellenti architetti, pittori et scultori italiani da Cimabue insino a' tempi nostri*, Florence 1550 (II ed. 1568 - published by G. Milanesi, Florence 1906).

L. PUNGILEONI, *Memorie istoriche di Antonio Allegri detto il Correggio*, 3 vols, Parma 1817-21.

A. VENTURI, "Nuovi quadri del Correggio", in *L'Arte*, 1907, IV, pp. 310-320.

R. LONGHI, "Il Correggio nell'Accademia di S. Ferdinando a Madrid e nel Museo di Orléans", in *L'Arte*, XXIV, 1921, pp. 1-6.

A. VENTURI, *Storia dell'Arte italiana*, IX, *La pittura del Cinquecento*, II, Milan 1926.

C. RICCI, *Correggio*, Rome 1930.

S. DE VITO BATTAGLIA, *Correggio. Bibliografia*, Rome 1934.

E. BODMER, *Il Correggio e gli emiliani*, Novara 1943.

F. BIANCONI, *Tutta la pittura del Correggio*, Milan 1953, II ed. 1960.

R. LONGHI, *Il Correggio nella Camera di S. Paolo*, Milan 1956, II ed.

A. E. POPHAM, *Correggio's Drawings*, London 1957.

R. LONGHI, "Le fasi del Correggio giovane e l'esigenza del suo viaggio romano", in *Paragone* IX, 101, 1958, pp. 34-53.

L. SOTH, "A note on Correggio's Allegories of Virtue and Vice", in *Gazette de Beaux-Arts*, LXIV, 1964, pp. 297-300.

A. GHIDIGLIA QUINTAVALLE, "Ignorati affreschi del Correggio in San Giovanni Evangelista a Parma", in *Bollettino d'arte*, L, 1965, pp. 193-9.

E. VERHAJEN, "Eros et Anteros. L'education de Cupidon et le prétendue 'Antiope' du Corrège", in *Gazette de Beaux-Arts*, LXV, 1965, pp. 321-40.

M. LASKIN, "A New Correggio for Chicago", in *The Burlington Magazine*, CVIII, 1966, pp. 190-3.

E. VERHAJEN, "Correggio's Amori di Giove", in *Journal of the Warburg and Courtauld Institutes*, XXIX, 1966, pp. 160-2.

A. C. QUINTAVALLE, in *L'opera completa del Correggio*, Milan 1970.

S. J. FREEDBERG, *Painting in Italy 1500 to 1600*, London 1971.

D. A. BROWN, "Correggio's Virgin and Child with the Infant St. John", in *Museum Studies. The Art Institute of Chicago*, VII, 1972, pp. 7-33.

H. DAMISCH, *Théorie du nuage. Pour une histoire de la peinture*, Paris 1972.

A. GHIDIGLIA QUINTAVALLE, "La Deposizione e il Martirio del Correggio dopo il restauro", in *Bollettino d'arte*, LVIII, 1973, pp. 213-14.

S. BÉGUIN, "Remarques sur les deux allégories de Corrège du Studiolo d'Isabella d'Este", in *Revue du Louvre*, 25, 1975, pp. 221-6.

C. GOULD, *The paintings of Correggio*, London 1976.

E. BATTISTI, in *L'abbazia benedettina di San Giovanni Evangelista a Parma*, Parma 1979 (edited by B. Adorni) pp. 106-32.

J. SHEARMAN, "Correggio's Illusionism", in *La prospettiva rinascimentale* (edited by M. Dalai Emiliani), Florence 1980.

VAR. AUTHORS, *Rivedendo Correggio. L'Assunzione nel Duomo di Parma. Come si fabbrica un paradiso* (edited by L. Fornari Schianchi e E. Battisti), Rome 1981.

G. ERCOLI, *Arte e Fortuna del Correggio*, Modena 1982.

E. RICCOMINI, *La più bella di tutte. La cupola del Correggio nel Duomo di Parma*, Parma 1983.

J. SHEARMAN, *Arte e illusione - Raffaello, Pontormo, Correggio*, Milan 1983.

D. DE GRAZIA, *Correggio e il suo lascito*, Parma-Washington 1984.

P. MOREL, "Morfologia delle cupole dipinte da Correggio a Lanfranco", in *Bollettino d'arte*, 23, 1984, pp. 1-34.

G. BRIGANTI, in *Nell'età del Correggio e dei Carracci*, Bologna 1986.

D. EKSERDJIAN, "Correggio in Parma Cathedral: not Thomas but Joseph", 1986, vol. CXXVII, no. 999, pp. 412-15.

VAR. AUTHORS, *Il Correggio e la Camera di San Paolo* (edited by F. Barocelli), Milan 1988.

M. DI GIAMPAOLO - A. MUZZI, *Correggio, i disegni*, Turin 1988.

P. PIVA, *Correggio giovane e l'affresco ritrovato di S. Benedetto in Polirone*, Turin 1988.

G. ALMANSI - C. GOULD, "Giove ti ama", in *F.M.R.*, 74, 1989, pp. 49-64.

P. P. MENDOGNI, *Il Correggio a Parma*, Parma 1989.

A. TISSONI BENVENUTI, *Nicolò da Correggio e la cultura di corte nel Rinascimento padano*, Reggio Emilia 1989.

A. ARBASINO - F. HASKELL, *La cupola del Correggio in San Giovanni a Parma*, Parma 1990.

VAR. AUTHORS, *Il monastero di S. Paolo* (edited by M. dall'Acqua), Parma 1990.

L. FORNARI SCHIANCHI, in *Un miracolo d'arte senza esempio. La cupola del Correggio in San Giovanni Evangelista*, Parma 1990, pp. 59-81.

L. FORNARI SCHIANCHI, "L'enfant mélancolique", in *F.M.R.*, no. 27, 1990, pp. 85-108.

C. GOULD, "La vertu mutilée", in *F.M.R.*, no. 27, 1990, pp. 77-84.

G. ADANI, "Per una lettura aggiornata del Correggio", in *Correggio identità-storia di una città*, Parma 1991, pp. 229-53.

M. DI GIAMPAOLO - A. MUZZI, *Correggio*, complete catalogue, Florence 1993.

Index of Illustrations

Other artists